series edited by Francesco Bonami

supercont

mporanea

text by Sarah Cosulich Canarutto

Koons

Electa

Made in Heaven. Much loved and cri
Jeff Koons has always attracted powerf
only a few years for the prices of his work
power of his art, two decades passed b
Koons's ability to represent the values ar
eighties artist par excellence, the perso
their mark on a concrete and sometime
ties and excesses. Jeff Koons draws c
visiting mass-produced consumer good

ized, the work of the American artist
nd conflicting responses. Though it took
o rise sharply, sanctioning the seductive
ore most critics agreed in recognizing
esires of a whole period. Koons was the
cation of those social changes that left
uperficial society born of both opportuni-
he aesthetic of everyday objects by re-
uch as toys, food and home appliances

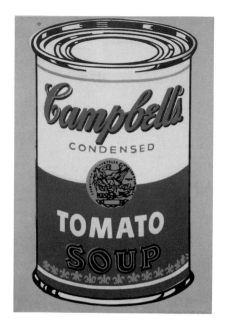

Andy Warhol
Four Colored Campbell's
Soup Cans, detail
1965 (II)
Acrylic and silkscreen
on canvas
92 × 61 cm
Sonnabend Collection

in a new version of the Pop Art which created a true artistic revolution during the sixties. In that period Andy Warhol with other artists, such as James Rosenquist, Robert Rauschenberg and Roy Lichtenstein (to name only a few), fused art and everyday life by using ordinary objects, popular icons and advertisements in their work. Their canvases, lithographs and sculptures, though colorful and seeming to celebrate an affluent historical period, actually embodied a critical—or at least ironic—attitude towards a society easily swayed by the media that was then developing. The period was distinguished by an exaggerated cult of appearances, aggressive media communications and a voracious consumer ethic. New canned foods, revolutionary detergents, new brands of cigarettes and famous movie stars were all elevated by Pop Art into new myths and mass icons.

By the way it incorporated banality and converted the everyday into art, Koons's work immediately appeared closely related to the art of Andy Warhol and this led to its being called "Neo-Pop." In the eighties, however, popular aesthetics immediately had further developments: it was no longer the result of the optimism of the post-war period but part of a complex consumer culture driven by the unconscious and people's aspirations. Koons testifies to a new collective mythology, a fabulous and innocent world driven by nostalgia and desire.

This approach, seemingly superficial, does not however fail to draw also on the artistic movements of the seventies, such as Conceptual Art and Minimalism. Inspired by cultural and social battles, these movements looked on the work of art as the starting point for developing alternative models. With a political attitude and a committed approach, Conceptual Art questioned the very meaning of the artwork itself, its mechanisms and definitions. Though not politicized and always concrete, many of Koons's works likewise make use of images or objects that embody metaphorical messages that allude to the art system itself.

Another important movement in the seventies was Minimalism. With its restraint, austerity and linear forms it became the mirror of a period that denied both material and ideological excesses. In this approach, artworks, consisting of simple repetitive elements, were meant to contribute to the redefinition of space and its perception.

Salvador Dalí
The Persistence of Memory
1931
Oil on canvas
24.1 × 33 cm
Museum of Modern Art,
New York

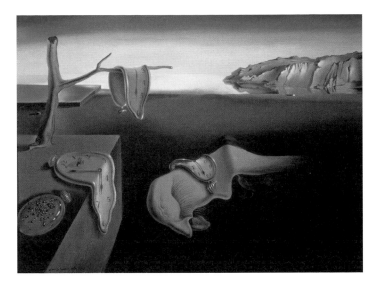

Koons often draws on Minimalism through visual juxtaposition, as appears by his use of neon tubes or spare modular vitrines, which are direct quotations from artists like Dan Flavin and Donald Judd. However, the Minimalist quality in Koons can be identified above all in the way he uses existing objects, which he takes over or incorporates into his works: his "ready-mades." However baroque and kitsch his works may appear, the artist chooses never to distort completely the context of the original iconographic source. While the ready-made (first introduced in 1913 by the French artist Marcel Duchamp) can be defined precisely as a common mass-produced object (altered or unaltered) isolated from its functional context, Koons prefers never to remove his objects from their original setting so as to preclude a unilateral interpretation of his work. The vacuum cleaners set in vitrines retain their integrity, the advertising icons their power of seduction, the comic-strip scenes their innocence and the eroticism its mystical and idealized qualities. While Duchamp and Warhol removed the ready-made from its context and raised it to a different level, Koons chooses never to dissociate it entirely from the reality of which it is a part.

But who is Jeff Koons? And how did he become one of the world's most important artists so rapidly? His work remains largely veiled by mystery precisely because the artist rarely gives himself away to criticize the colorful and superficial world he depicts. Koons does not condemn the system but observes it, deconstructs it and plays with it creating his own rules. The "pop" world no longer suggests fantasy (as in the sixties) but reality: middle-class America has now attained a greater level of prosperity in which consumerism is the greatest common denominator. Koons's own biography traces a positive and optimist picture of the figure of the artist, as if this time art was itself paradoxically integrated into the society it mirrors. Born into a middle-class family living in the suburbs, his creativity was encouraged by his parents, who sent him to have art lessons at an early age. His father, especially proud of his son's achievements, displayed and sold his drawings in his furniture store. Koons chose to finish his studies at the Art Institute of Chicago, at a time when various representatives of the Chicago School of Pop were teaching there: they included Jim Nutt and Ed Paschke, artists he particularly admired. Later he moved to New York

Robert Rauschenberg
Retroactive II
1964
Oil, silkscreen on canvas
213 × 152 cm
Stefan T. Edlis Collection

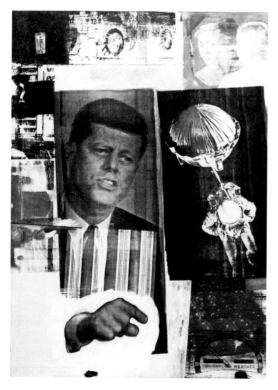

and began to work part-time at the membership desk of the Museum of Modern Art. Here, apart from having plenty of opportunities to view masterpieces of art history, he revealed considerable entrepreneurial flair by doubling the donations to the museum. To fund the production of his works, Koons left MoMA and accepted a position as a Wall Street broker working on commission. Only after his first important show in 1985 did he decide to leave the stock exchange and devote himself entirely to art.

Right from the start of his career Koons preferred spectacular materials that made a strong visual impact but were quite costly. These were years when people were earning money and spending extravagantly. How could the artist reflect all this except by embodying the same principle? Bronze, porcelain and stainless steel required highly complex production processes carried out in specialist factories. Koons's studio was soon transformed into a true workshop employing dozens of skilled assistants precisely because the artist, known for his precision, was unwilling to compromise on even the smallest detail.

Koons transformed the banality of the ordinary into a captivating and vital necessity with his early

Marcel Duchamp
Fountain
1917/1964
Urinal made of porcelain
33 × 42 × 52 cm
Moderna Museet, Stockholm

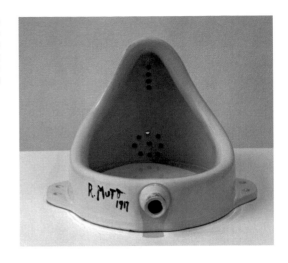

inflatable animals and flowers, which celebrate the seduction of innocence and present home appliances as eroticized metaphors of innovation and well-being. These works in the series of "The New" were eye-catching: they conveyed optimism and actually fomented the acquisitiveness that was the very quality they paradoxically seemed to question. This was in the early eighties, a period when there was the growing demand for luxury goods, the cult of leisure, an obsession with brand names as emblems of unrestrained consumerism. Koons reacted to the aesthetics of excess by celebrating it with an iconography that was equally exaggerated. He probed the weaknesses of his public and made them the strong point of his art. In the Nike posters of the "Equilibrium" series, which Koons framed and exhibited unaltered, the artist showed, for example, how the great American sporting figures personified a universally shared form of social and financial success. Sport in that period, like the cinema in the sixties, was the new frontier of fame, it created icons whose popularity cut right across society and possessed an almost magical power. But the eighties celebrated leisure as much as pleasure, and this is reflected in Koons's decision to present posters of different brands of liquor. This work, titled "Luxury and Degradation," brings out the manipulative power of the adman's language, which tailors messages to suit a particular social class and the income bracket of its target group. While the Nike posters link up with Warhol's versions of Marilyn Monroe and the whisky posters with his Campbell's Soup cans, the distance between life and art seems even shorter in Koons. Unlike Warhol, he does not alter the context or modify the image but often allows their transposition into the artistic field to bring out their singularity and paradoxical qualities.

Koons's works play on contrasts, and not just iconographically. His choice of materials is equally important since it aims to overturn the rules generally associated with the idea of art. With plastic flowers, kitsch china figurines, gigantic stainless steel toy animals, his works look like outsize furnishings, as if the artist wanted to confuse art with decoration. At the same time, while Koons seeks to efface the mental boundaries that distinguish art from craftsmanship, he also distances himself from the physical making of the work. By employing numerous assistants and

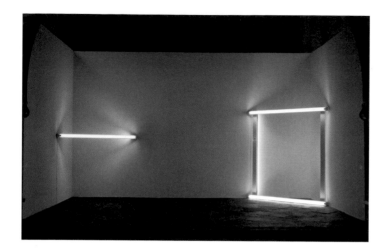

Dan Flavin
**Untitled
(to Ileana and Michael
Sonnabend)**
1970
Blue, yellow, red fluorescent
tubes
244 cm

**Untitled
(to the Innovator
of Wheeling Peach Blow)**
1966–68
Pink, gold and natural daylight
fluorescent tubes
244 × 244 cm
Sonnabend Collection

commissioning work from specialized factories, he plays ambiguously with the relationship between art and technology.

This was also the period of New Wave music, which used electronic sounds to alter the aesthetics of melody and a period when fashion went in for increasingly bright hi-tech colors. In an age of back-brushed hairstyles, metal ribbons, lace and ruffles and food that comes in ever-more fanciful colors, Koons testifies to a world where kitsch reigns supreme.

The "Made in Heaven" series of posters, which represents the artist and the famous Hungarian porno star Ilona Staller (professionally called "Cicciolina") in a variety of erotic positions, presents the aestheticization of contemporary desire. The artist used complex settings that recall the rococo paintings of Bouchet and Fragonard, and created a modern imagery of transgression in "early nineties style." He sought to fashion a new image of sin that would replace the figures of Adam and Eve in the paintings of the Old Masters by supplying a new painting with which we can all identify ourselves. In Koons's work, Cicciolina (who made Italy her home and between 1987 and 1992 was elected to Parliament as a

representative of the Italian Radical Party) became a ready-made, a pre-constructed character to be set in the same context of which she is normally a symbol.

The relationship between Koons and art history also led him explore the concept of monumental sculpture, with *Puppy* as the classic example. The artist himself tells us that *Puppy* is about man's relationship with God and the idea of eternity. The paradox between the beauty of the sculpture, made up of thousands of flowers, and its precariousness due to difficulties of maintenance have generated a form of glorification from which the action of man can never be excluded. Koons celebrates the vanity of the banal and the surface of the artifice: it is for this reason that the reflecting materials used in the "Celebration" series prevent the viewer's gaze from ever penetrating further but rebound and are reflected again on himself.

Also his paintings in the "Easyfun-Ethereal" series produced around the beginning of the new millennium deny any precise iconographic hierarchy in favor of a kaleidoscope of forms that metaphorically represent the surface of the world. Koons works with the Surrealism of Salvador Dalí,

Jeff Koons
**One Ball Total Equilibrium
Tank (Spalding Dr. J. Silver
Series)**
1985
Glass, steel, sodium chloride
reagent, distilled water,
one basketball
164.5 × 78.1 × 33.7 cm

one of his favorite artists; he transcends the dreamlike to return again to the visual trap in which our eyes are imprisoned every day. Skillfully composed through prior digital construction, the canvases play with the observer: comic-book and reality, two-dimensional surfaces and volumes, Pop and tradition. Koons's collages become colored prisons in which we can wander and dream, look at ourselves reflected in mirrors and have fun, but from whose seduction neither our imagination nor our unconscious will be able ever to struggle free.

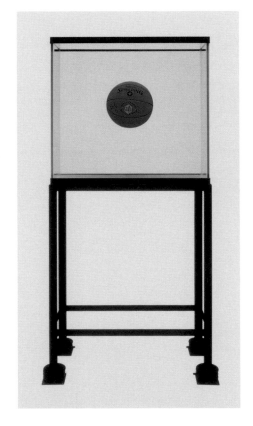

works

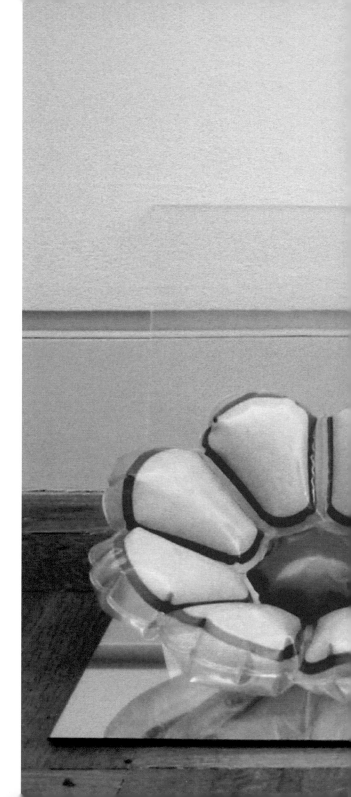

**Inflatable Flowers
(Short Pink, Tall Purple)**
1979
Plastic, mirror, and Plexiglas
40.6 × 61 × 45.7 cm

From the first, Koons's works expressed
the seductive playfulness characteristic
of his art. The celebration of banality is
embodied in these two inflatable flowers,
symbols of a childlike ingenuousness
but at the same time sexual allegories and
metaphors of consumerism. If the inflatable
component emphasizes the precariousness
of a world built on appearances, the use
of plastic represents the triumph of an
artificiality multiplied in the mirror and
denying the image the power to penetrate
below the surface of the things.

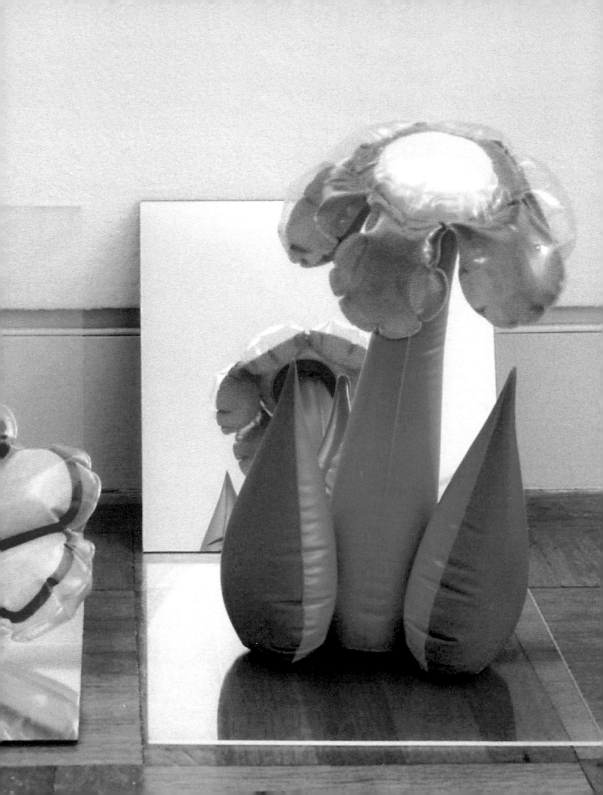

**Inflatable Flower and Bunny
(Tall White, Pink Bunny)**
1979
Plastic and mirrors
61 × 30.5 × 81.3 cm

The glorification of superficiality is
exemplified by Koons in the juxtaposition
of two icons of beauty taken from media
imagery. The animal and the flower are two
classic advertising images that are isolated
from their associated promotional messages
to become vehicles of their own power
of communication. A bunny that knowingly
holds a carrot and a stylized daisy look
into the mirror and project the viewer
into their cheerful, colorful world.
In this image the artist ambiguously fuses
nostalgia and seduction, fable and reality,
innocence and desire.

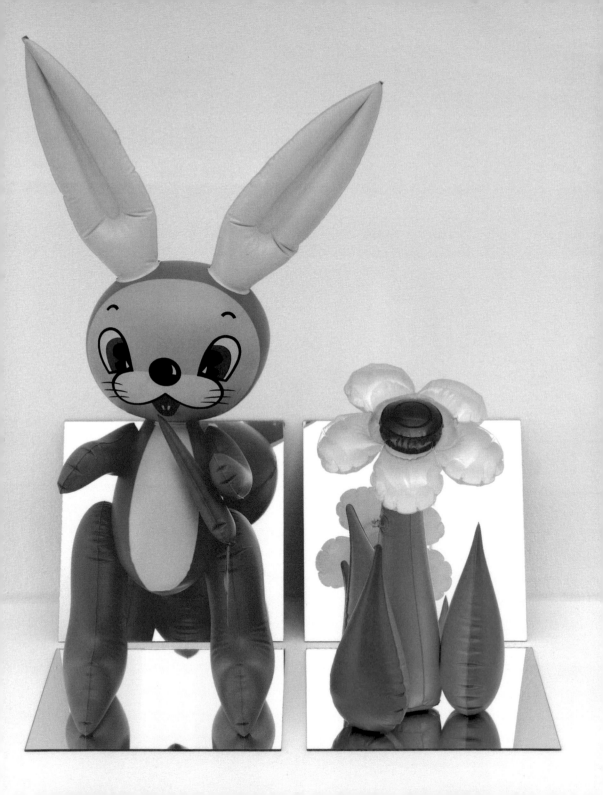

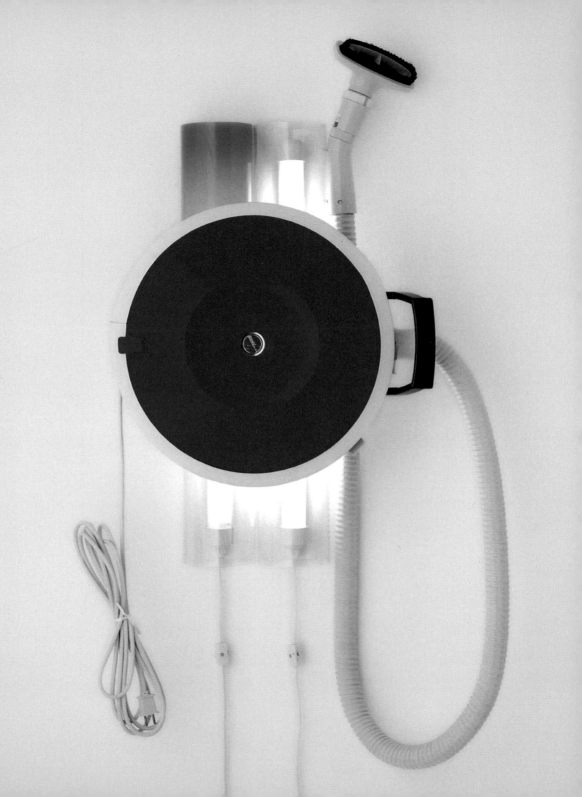

Hoover Celebrity III
1980
Vacuum cleaner, acrylic, fluorescent lights
96.5 × 50.8 × 27.9 cm

Continuing with the "ready-made"
introduced by Marcel Duchamp and
commonly used in Pop Art, Koons raises
humdrum objects to the status of works
of art. Unlike Duchamp, Koons does not
set the object in a new context, and unlike
Andy Warhol he has no axe to grind with
consumerism. Instead he chooses to
emphasize the integrity of a consumer
object by showcasing it in a neon light that
imitates a showcase. The vacuum cleaner
exalts the power of seduction of cleanliness,
displaying one of the aesthetic models
of the American middle-class.

Toaster
1979
Toaster, acrylic, fluorescent lights
33 × 68.6 × 22.9 cm

Here an ordinary toaster forms a contrast
to the verticality of the neon tube supporting
it. Once again Koons plays with the intrinsic
features of the objects of everyday use by
relating them to the history of art. The neon
tube becomes a quotation from the
Minimalism of Dan Flavin, while the toaster
appears in its abstract geometrical value
as a glossy and regular shape. In reality,
behind the apparent banality of this image,
the artist again conceals an explicit sexual
reference obvious in the juxtaposition
of the shapes.

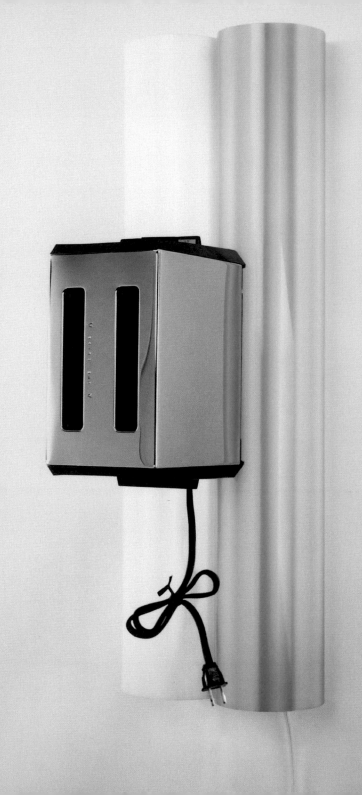

Teapot
1979
Teapot, acrylic, fluorescent lights
66 × 22.9 × 30.5 cm

The symbol of a middle-class ritual now
become a banal mass activity, the teapot
is another object that Koons isolates and
synthesizes in his interpretation of everyday
life. This is also an instrument that
embodies an implicit action, a process
of transformation stimulated allusively
by the warmth of the light to which it is
connected. The artist presents new and
intact objects that restore a sacral quality
to the gestures with which they are
associated, raising the culture of mass
consumption to art.

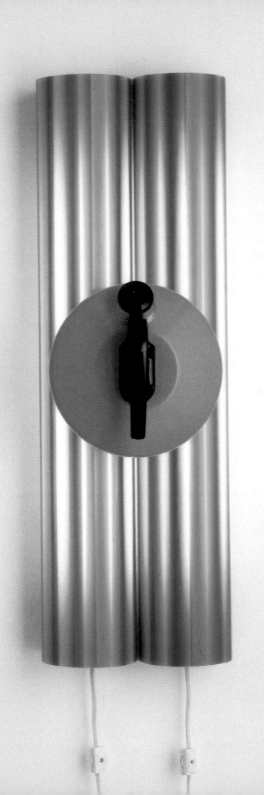

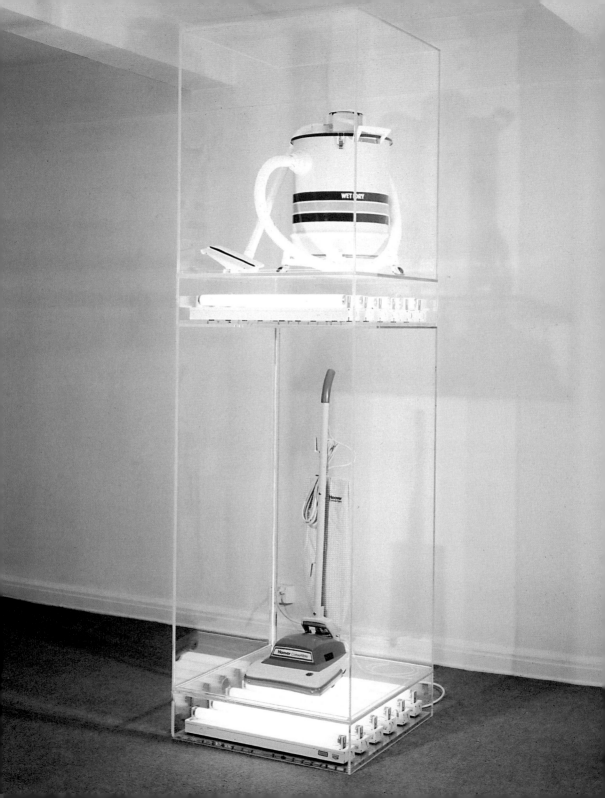

**New Hoover Convertible, New Shelton
Wet/Dry 10 Gallon, Doubledecker**
1980
Two vacuum cleaners, Plexiglas, fluorescent
251.5 × 71.1 × 71.1 cm

Koons sees everything requisite for art as
already present in the world, hence there is
no need to invent it. In this work the artist
combines sarcasm in the promotion of a
consumer good with a clear allusion to the
Minimalism of Donald Judd and Dan Flavin.
With the vacuum cleaner the aesthetics
of cleanliness and order are given a literal
embodiment. The purity of their form and the
presentation express both an urge
to simplify the artistic message and
the complex mechanisms that determine
the effectiveness of an ad.

The New Jeff Koons
1980
Duratran, fluorescent light box
106.7 × 81.3 × 20.3 cm

This image of the artist as a little boy
is closely bound up with "The New" series,
in which Koons celebrates the integrity
and novelty of everyday consumer products.
In this case it is childhood with its
ingenuousness and incorruptibility that
becomes an image of an ideal world and
a symbol of the noblest artistic aspirations.
The black and white photo is transferred
onto a light box, an instrument that modifies
its interpretation by transforming it from
a simple personal memory to a poster
of an uncontaminated vision of the world.

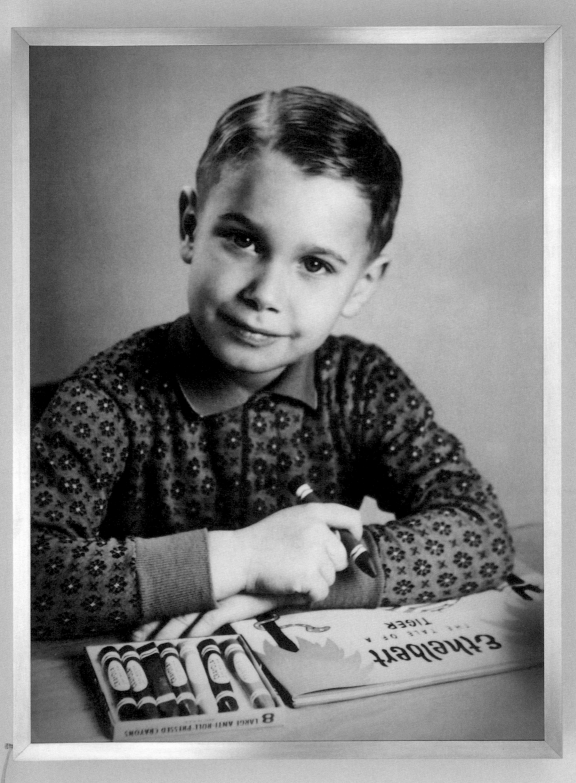

Ironically but literally translating Donald Judd's Minimalist principles, which favor the modular replica of individual elements in space, Koons places everyday consumer goods in a sealed transparent plastic showcase.

Neon tubes underscore the irreverent allusion to Dan Flavin's Minimalist use of light. Here the neon tube is no longer an element metaphorically defining spatial relationships but represents Koons's urge to recreate an attractive display that looks like a store window.

A banal object like a vacuum cleaner contains the aesthetics of novelty and the consumer's craving for modernity common among middle-class Americans. Home appliances become eroticized images, modeled by the acquisitiveness typical of the affluent society. Koons negates their function by setting them in a cage that transforms them into class symbols, metaphors of optimism or decadence, icons of a period when everything is advertising.

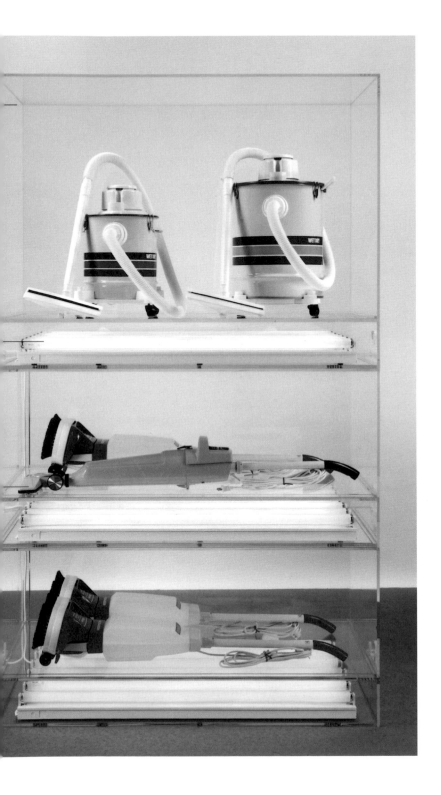

focus

**New Hoover Deluxe
Shampoo Polishers,
New Hoover Quik
Broom, New
Shelton Wet/Drys,
Tripledecker**
1981–87
Vacuum cleaners,
Plexiglas, fluorescent
lights
294.6 × 137.2 × 71.1 cm

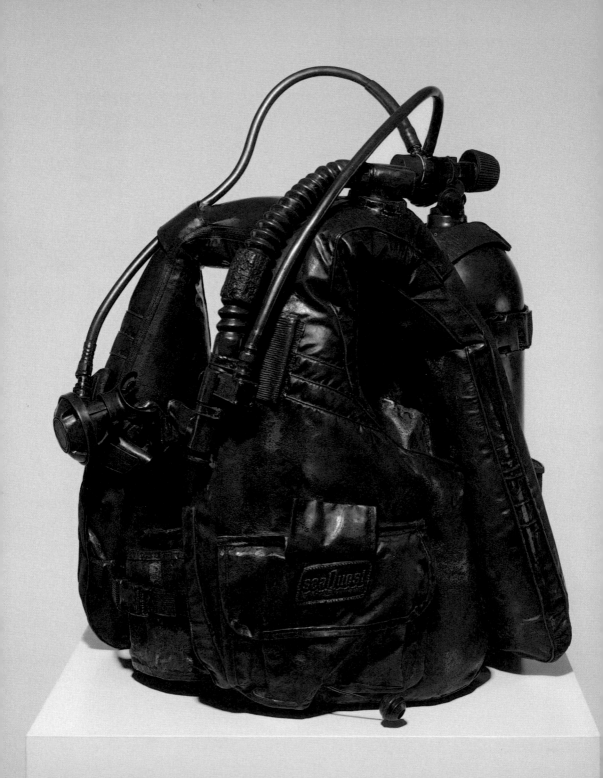

Aqualung
1985
Bronze
68.6 × 44.5 × 44.5 cm

In this bronze sculpture Koons fuses
tradition and perception. An everyday object
commonly associated with a leisure activity
becomes a classic work of art and, through
its associations with sculpture, evokes the
past. In this way the artist plays on
contradictions: on the one hand he restores
the instrument's apparent lightness while on
the other he transforms it into a concrete
representation of its contrary. Banality
encounters the history of art and so creates
a sculpture of baroque perfection that
yet exclusively evokes the superficiality
of mass entertainment.

In the mid-eighties at
an exhibition Jeff Koons
presented a series of
works inspired by the idea
of balance. This was
a group of Nike posters
celebrating contemporary
sports heroes,
recontextualized by
the artist as images
symbolizing mobility and
social conquests. Koons
combines the photos
portraying these sports
legends with sculptures
that reproduce the
principle of balance
both conceptually
and concretely.

A standard fish tank
is converted into
a minimalist display
case within which three
basketball balls float
mid-way between the air
and the water. This is
setting is also precarious
metaphorically but in
reality it is not easily
sustainable. Koons sees
equilibrium as a social
consensus, as a form
of success of which sport
is a fundamental example.

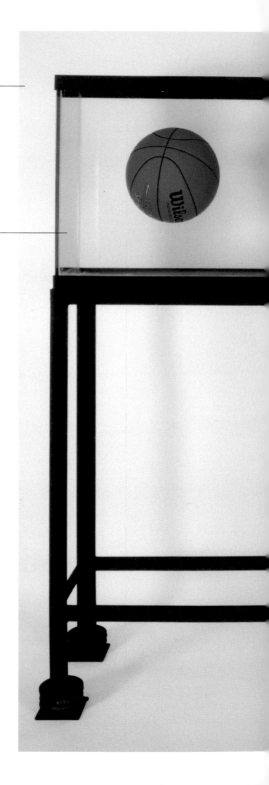

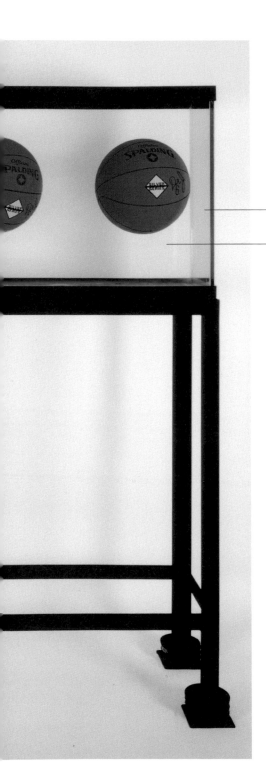

Once again the display case is the vehicle that communicates an image. On the one hand the container again alludes to Minimalism, but on the other it negates it by expressing a kitsch significance bound up with the consumer culture of display.

In taking a ball as the subject of this work, Koons emphasizes the correspondence between art and sport. Just as many ethnic groups pursue success in sport as a way of raising themselves socially, white middle-class Americans see art as a possible instrument of distinction and emancipation.

Three Ball 50/50 Tank
1985
Glass, steel, distilled water, three basketballs
153.7 × 123.8 × 33.7 cm

Dr. Dunkenstein
1985
Framed Nike poster
115.6 × 80 cm

The series of Nike posters forming part
of the "Equilibrium" series represent
Koons's interest in the clichés of advertising.
In the mid-eighties he exhibited, with
the manufacturer's permission, a group
of promotional manifestoes left unaltered.
Set in an artistic context, these
posters/ready-mades became depictions
of contemporary idolatry in the form
of a morbid celebration of sporting myths.
From magicians to presidents, from
prophets to doctors, the "heroes"
communicate a dream and so acquire
an almost religious power.

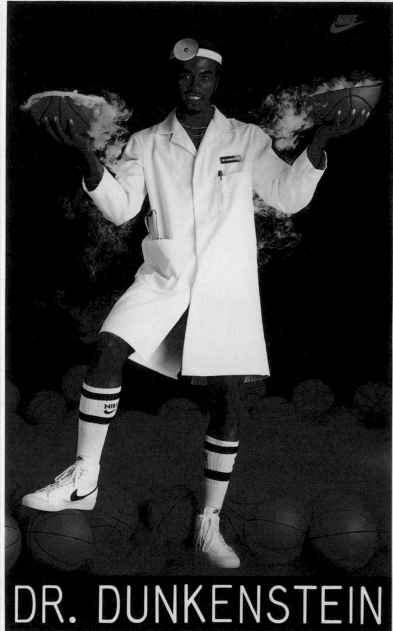

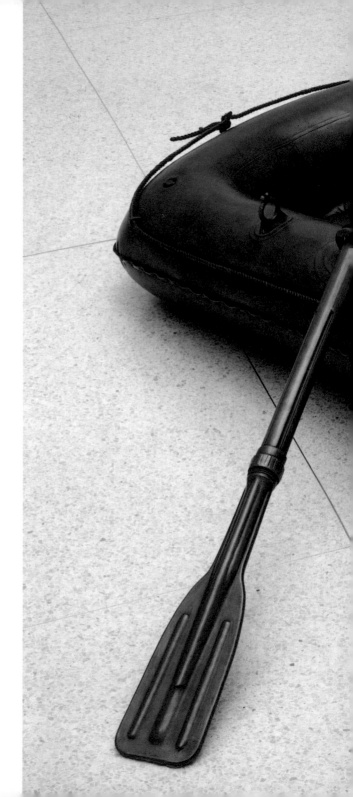

Lifeboat
1985
Bronze
88.9 × 30.5 × 152.4 cm

In this work the artist again creates another kind of inversion of the subject. A rubber dinghy, the symbol of childish fun, associated with happiness and innocence, is turned into a solemn sculpture in which only careful scrutiny enables the viewer to identify the material it is made out of (bronze). Here, again, a banal object becomes a classic work whose material and artistic value invokes the standards of tradition. In raising itself to the plane of art, the lifeboat loses its intrinsic lightness, so denying the function it symbolizes.

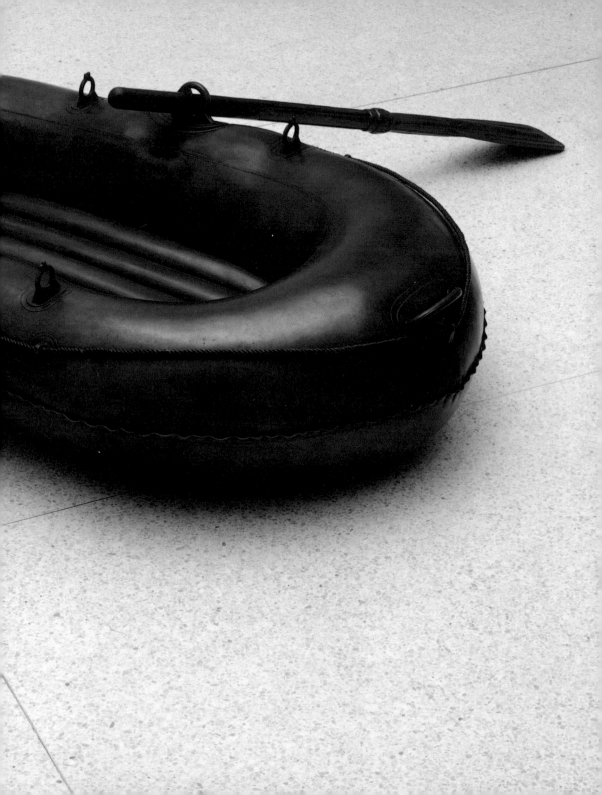

Aqui Bacardi
1986
Oil inks on canvas
114.3 × 152.4 cm

In *Aqui Bacardi* Koons transfers
to canvas an advertisement for a
well-known brand of liquor. As part of a
series titled "Luxury and Degradation,"
in which the artist stresses selling
strategies that aim to corrupt the
consumer, this work reveals the
weaknesses which sales campaigns
of this kind appeal to. Simply by
comparing different advertisements,
Koons emphasizes how the
iconography, and hence the promises
implicit in the consumption of a given
product, are carefully tailored
to different social classes.

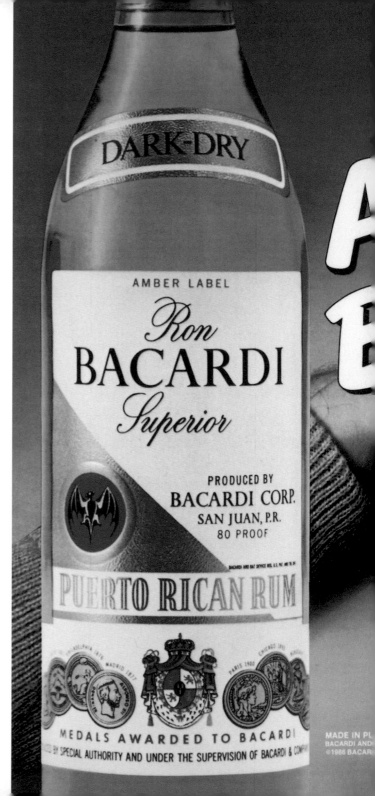

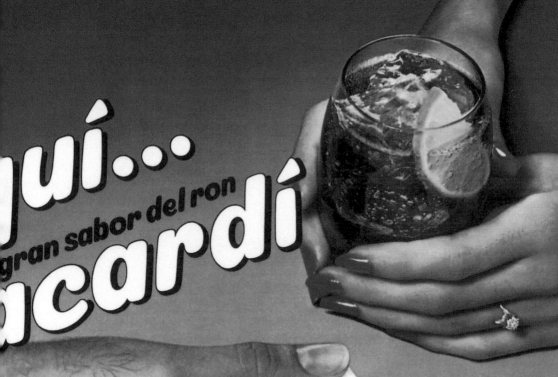

...quí...
gran sabor del ron
bacardí

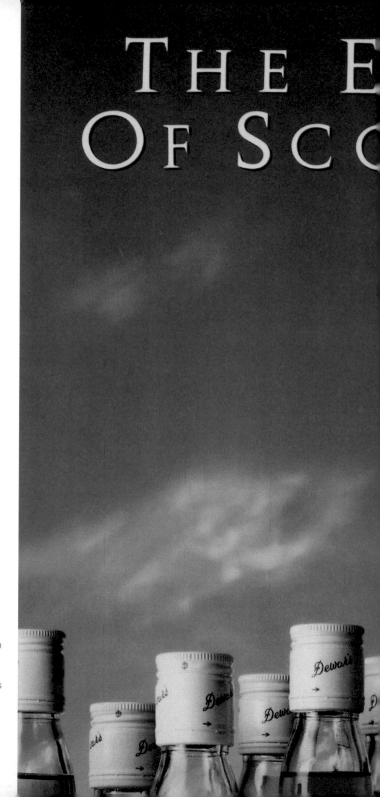

The Empire State of Scotch, Dewar's
1986
Oil inks on canvas
113 × 152.4 cm

Continuing his analysis of commercial manipulation of the masses, in this poster transformed into an oil painting on canvas Koons brings out the ploys adopted by advertisers to influence different social classes. While in certain placards the illusion that a brand of drink evokes is a night of pleasure, entertainment and sex, Dewar's seems to promote a more abstract and subtle kind of luxury intended to evoke a search for sophistication and "spiritual" elevation among the more affluent classes.

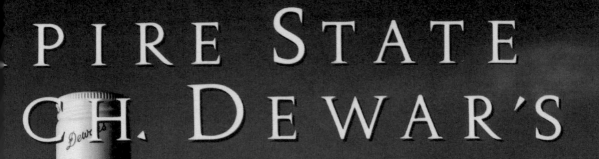
PIRE STATE
CH. DEWAR'S

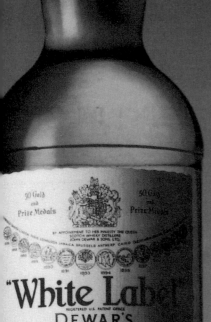

A sparkling object
of desire, luxurious
and decadent, the
*Jim Beam – J.B. Turner
Train* is a detailed replica
in stainless steel of the
toy train containing the
famous brand of alcohol.
This work formed part
of an important exhibition
of 1986 titled "Luxury
and Degradation" where,
together with glittering
and seductive objects
replicated in steel, Koons
presented a number
of canvases reproducing
ads for well-known brands
of alcohol. The artist's
intention was to present
a panorama of society
which, by bringing out the
dangers of degradation,
would deter the
irrepressible craving for
luxury, which Koons sees
as depriving individuals
of their economic and
political power.

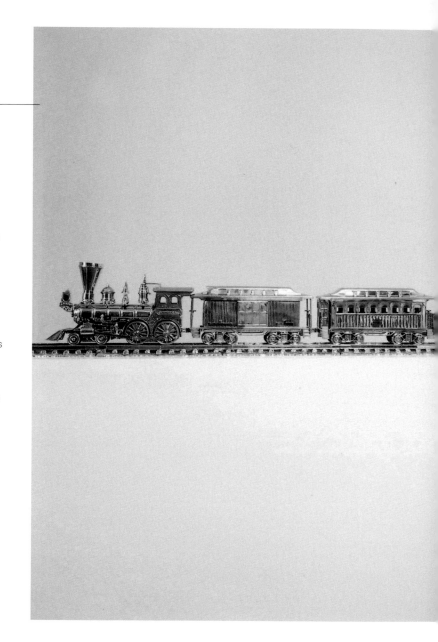

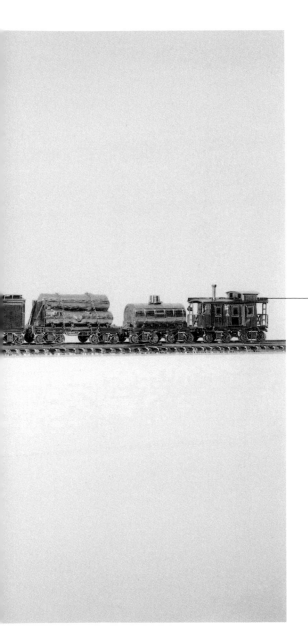

Refined and seductive, the new steel train works on the same principle as the promotional messages strongly criticized by Koons and so sets art on the same level as advertising. Propaganda for luxury items is effective in persuading the public to buy a product, but art uses the same trick. Paradoxically the work presented by Koons, though an evident kitsch metaphor for the manipulation of consumers, embodies the same mechanisms as the original because it is defined in accordance with the parameters of status and wealth.

Jim Beam – J.B. Turner Train
1986
Stainless steel
and bourbon
27.9 × 289.6 × 16.5 cm

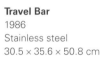

Travel Bar
1986
Stainless steel
30.5 × 35.6 × 50.8 cm

This portable bar recreated in stainless steel
likewise becomes a jewel-object that exalts
the power of ostentation and the unfailing
degradation implicit in it. Alcohol is again
a metaphor for class, mass indulgence and
social cement. However, this work, an exact
replica of the original, denies its principal
function by its choice of material. From being
a portable article, the object is turned into
the maximum embodiment of uselessness,
desire and dependency, yet the same
that Koons's art also helps to shape.

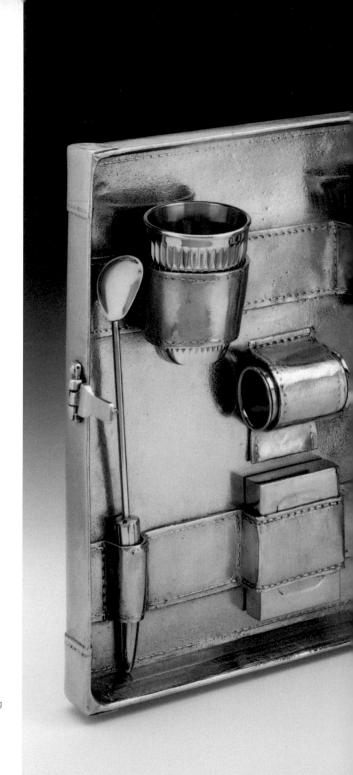

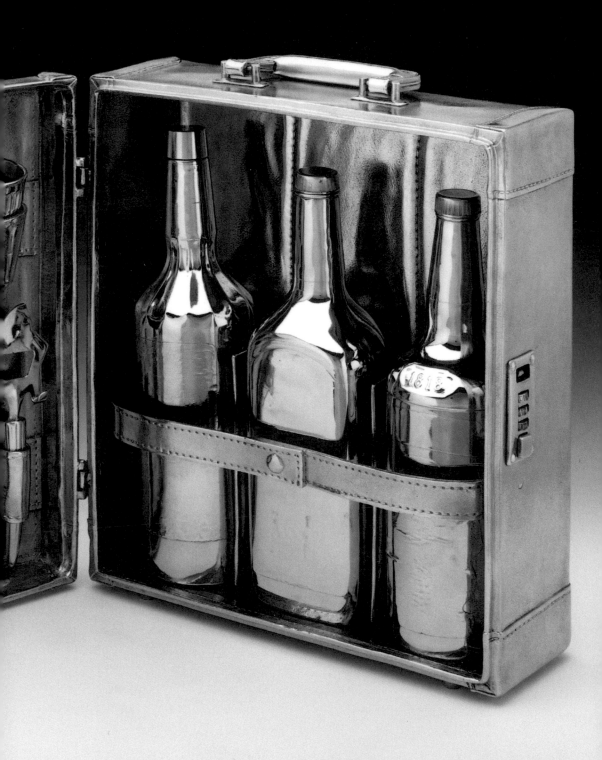

This stainless steel rabbit, based on inflatable versions of children's toys, contains some of the principal themes of Koons's work, from his interest in natural elements such as air or water to comparison with kitsch. The object, typically associated with the fabulous and innocent world of childhood, is altered in scale and material and set in an artistic context. While the precision workmanship and careful detailing relate it to traditional sculpture, the choice of the subject negates the artist's desire to imitate the natural movement of things.

In fact the rabbit represents an artificial optimistic vision based on ingenuity and nostalgia inspired by banality.

Unlike the sculptures of the past, which were a form of commemoration reserved for the elite, Koons presents a universally recognizable and infinitely reproducible object. This apparently trivial toy is transformed into jewelry by its gleaming surface, which can mirror the world with its desires and contradictions. As in all his works, the artist returns to the surface of things, which are often given a mirror finish that reflects the viewer's gaze back to him.

Rabbit
1986
Stainless steel
104.1 × 48.3 × 30.5 cm

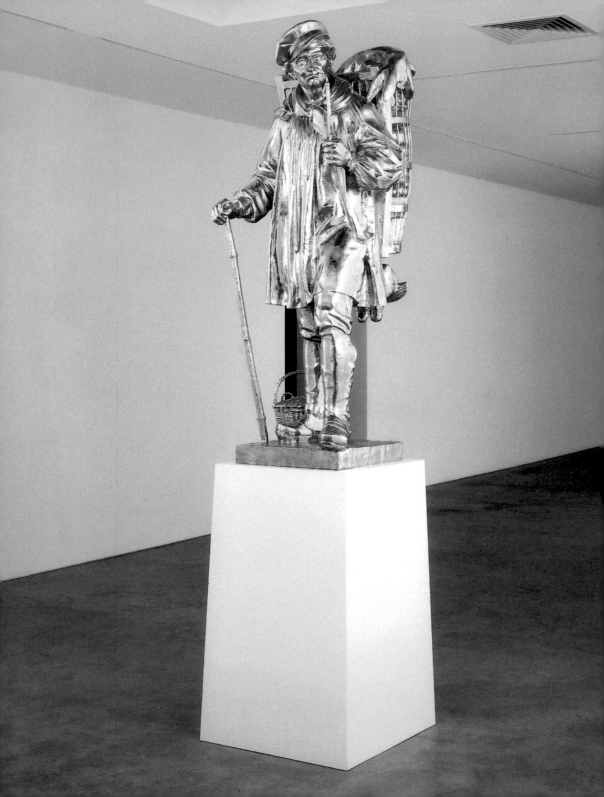

Kiepenkerl
1987
Stainless steel
180.3 × 66 × 94 cm

Koons produced this work for the major
exhibition of public sculptures held in
Münster, Germany, in 1987. It is a stainless
steel replica of the original bronze statue
celebrating the city's identity in the center of
Münster, symbolizing its self-sufficiency,
abundance and morality. By using a material
associated with the affluent proletariat to
reproduce the statue of the man carrying the
produce of the land to market, Koons sought
to give a contemporary version of a symbol
of economic security, nowadays no longer
agricultural but also industrial.

Buster Keaton
1988
Polychromed wood
180.3 × 66 × 94 cm

Koons presents the legendary movie-star
Buster Keaton in a bizarre sculpture in
painted wood that alters the scale of the
figure and evokes the kitsch and surreal
effect of a contemporary souvenir. It
creates the image out of a typical collage
of elements of popular culture. Keaton,
gloomily seeking something that we can
never identify, becomes a personification
of the absurd and, at the same time, a figure
that in its banality is a reassuring symbol
of mass entertainment and universally
recognized social hierarchies.

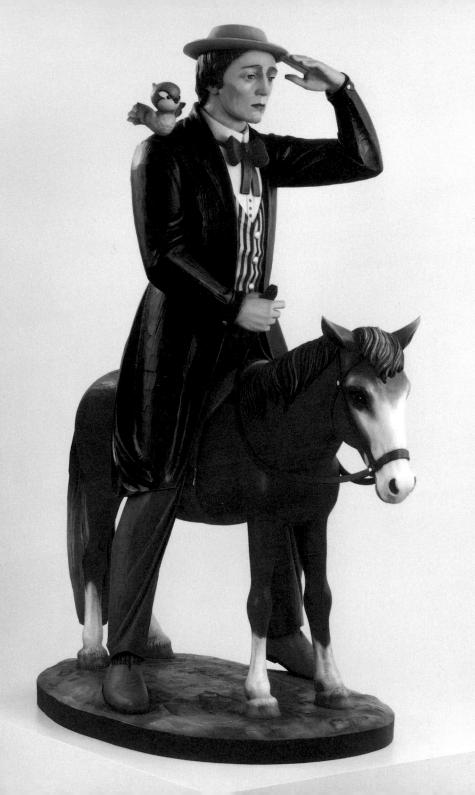

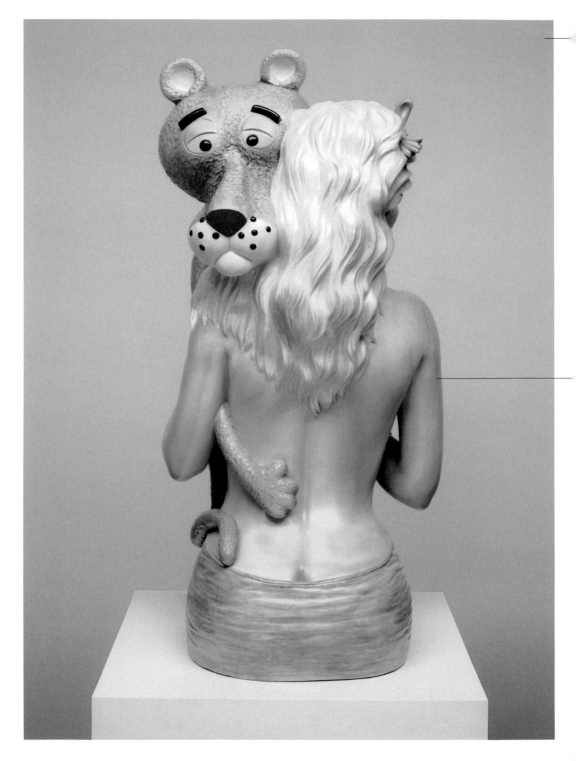

The innocent world of cartoons and the more provocative world of adults are incorporated by Koons into a work that celebrates the power of advertising in the media. The artist's first challenge lay in making the sculpture out of porcelain, a refined material but one that tends to be associated with craft works and not high art. The purpose is to undermine artistic parameters through a kitsch and pretentious effect to bring out the decorative element yet again.

The viewer is faced with two symbols par excellence of contemporary advertising. On the one hand a skimpily dressed blonde, sexy and seductive, smiling ambiguously and ready to convince consumers of the effectiveness of the product being advertised. On the other, the Pink Panther, a cartoon icon belonging to the imagery of childhood, often used in adverts, like many other cartoon characters. This allusive and ambiguous embrace sanctions an ironical alliance, a metaphor of the power of the media message.

Pink Panther
1988
Porcelain
104.1 × 52.1 × 48.2 cm

Michael Jackson and Bubbles
1988
Porcelain
106.7 × 179.1 × 82.6 cm

This work also forms part of the "Banality" series, in which Koons exalts artifice and the decadence of contemporary popular icons. Exaggerated decoration, kitsch and paradox are some of the features we find in this sculpture of Michael Jackson. Koons represents him with his monkey in an ornamental material (porcelain), altering his dimensions and amplifying disquieting details such as his pallor and the ostentation of glamour. The work, only seemingly innocent, prompts reflection on the mystifications of celebrity.

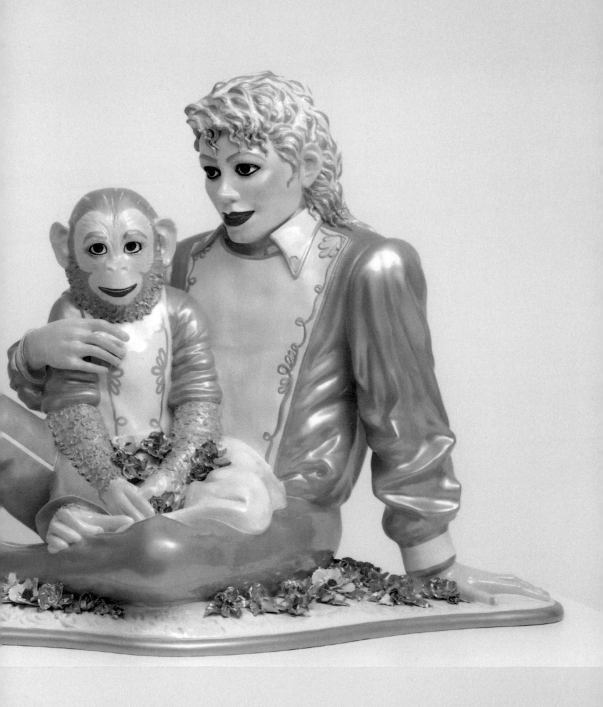

Stacked
1988
Polychromed wood
154.9 × 134.6 × 78.7 cm

An ambiguous interpretation of a well-known
fairy tale, this sculpture traces the
stereotypes of innocence and nostalgia
bound up with childhood. Using a traditional
material like wood and playing with the scale
and proportions, Koons creates a baroque
image, an absurd ornament resembling
a giant souvenir. The transposition of an
object that celebrates kitsch and futility
into the world of "high" culture stresses
the role of popular imagery in shaping
dreams and desires and then making them
the instruments of communication
or consumption.

Koons uses stereotyped elements and over-decoration to fuse classicism and Pop with a sense of ecstasy. The carefully staged scene creates a modern garden of Eden, both romantic and baroque, into which viewers can project their own desires.

At the end of the nineties Koons extended his interpretation of the ready-made to take in pornography. In reality, the images depicting the artist having sex with a well-known porno-star seek to achieve the opposite effect, underlining, in their philosophical analysis and the semiotics of the subject, the banality of the symbols and of the mechanisms intrinsic to it. "Made in Heaven" consists of a series of posters from works on canvas reproducing photos but also kitsch sculptures of flower vases and artificial garlands that, taken as a whole, are related to the rococo tradition of artists such as Boucher and Fragonard.

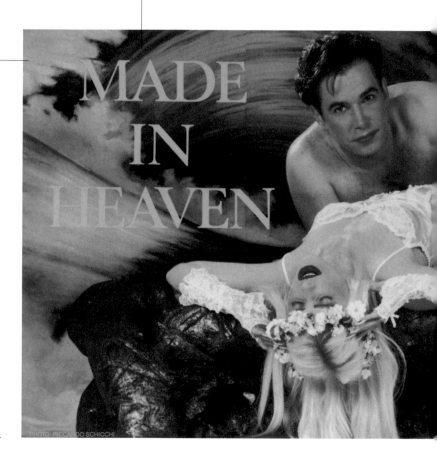

PHOTO: RICCARDO SCHICCHI

Here Koons challenges the double standard in contemporary society's dealings with sex and eroticism through a work that embodies a form of spirituality that rejects the feelings of guilt and shame normally associated with images of this kind. In this work the artist seeks to create an updated version of Masaccio's painting of *The Fall* in which Adam and Eve bare their temptations and, obliquely, the desires of the viewer.

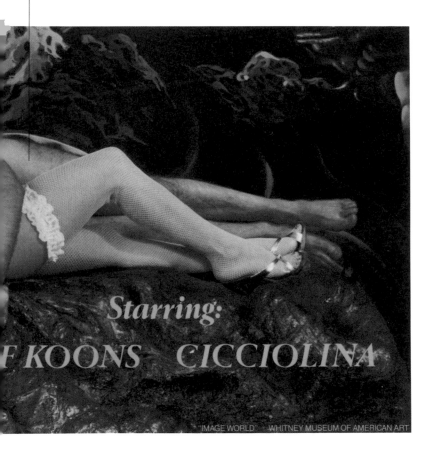

Made in Heaven
1989
Lithograph
billboard
317.5 × 690.9 cm

Self-Portrait
1991
Marble
95.3 × 52.1 × 36.8 cm

This self-portrait in marble forms part
of the "Made in Heaven" series, which
seeks to transform eroticism into spirituality.
In line with the kitsch and often decadent
quality of his work, Koons portrays himself
in an apparently classical way, in the guise
of a sensual deity born from an explosion
of splinters, while his ecstatic gaze evokes
Bernini's famous carving of Saint Teresa.
The artist often incorporates the concepts
of omnipotence and immortality into his
work; here he cites the past to shape
a new form of mystical experience.

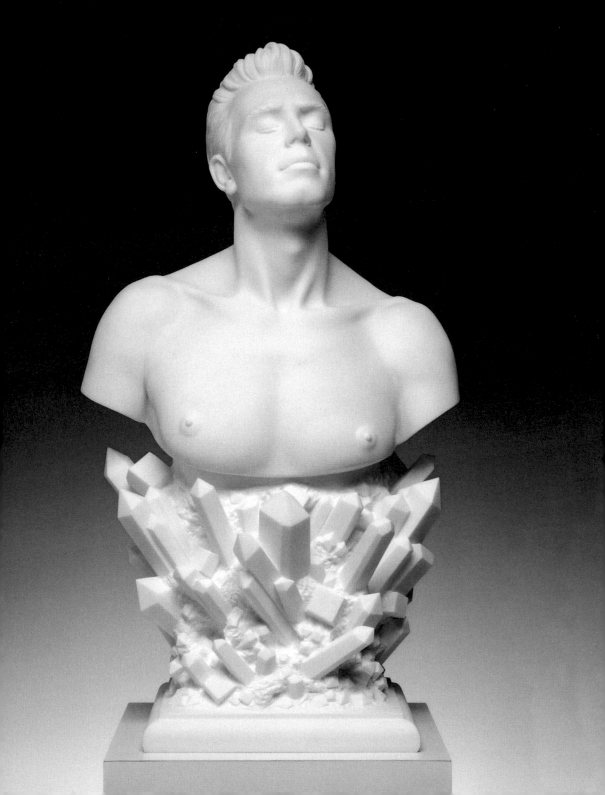

Puppy is one of Jeff
Koons's principal works
both by the complexity
of the sculpture, standing
twelve meters tall and
covered with some
70,000 plants, and its
ability to embody the
fundamental themes
of his art. Supported
by an outsize steel frame
that supports the flowers
and houses an irrigation
system, this giant puppy
confronts the viewer
with its beauty, ambiguity
and intensity. Koons saw
it as a work possessing
a powerful communicative
impact and a great
personal value. While
it is baroque in the
richness of its details,
it also has a minimalist
quality in its relationship
with the public.

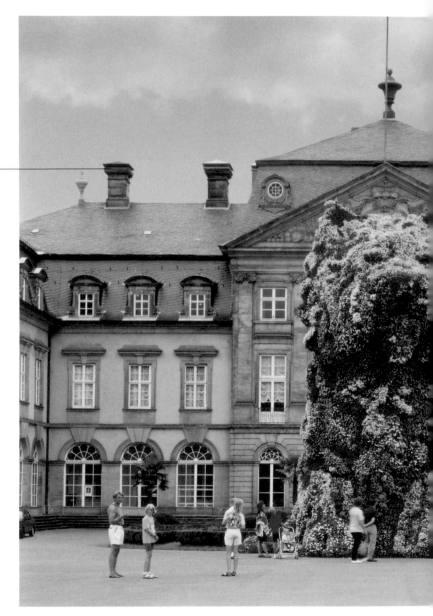

Puppy grew out of a dialogue with architecture and the artist's urge to create a work that would relate to the experience of space. Koons sees this work as about the relationship between God and Humanity and, in its progressive development and growth, it represents the concept of eternity itself. Originally installed in front of the Castle of Arolsen in Germany, the sculpture retrieves a romantic quality and fuses it with kitsch. By altering the dimensions of the puppy, a primary symbol of tenderness and playfulness, the artist transforms it into an icon of vanity and banality.

Puppy
1992
Stainless steel,
soil, geotextile fabric,
internal irrigation
system and live
flowering plants
1234.4 × 1234.4 × 650 cm
Formerly at the Castle
of Arolsen

In the mid-nineties Koons developed a new suite of works titled "Celebration". This was a series of photorealist paintings and monumental steel sculptures representing symbols and objects associated with the rituals of life, such as birthdays, vacations and other festive occasions.

Balloon Dog and *Moon* represent objects typically associated with children's parties, which Koons here subverts through their dimensions and materials. They are outsize, heavy sculptures that entirely contradict the idea of lightness they seem intended to embody. Inspired by the birth of his son, these works represent a change of direction in Koons's work that favored images conveying a sense of cheerfulness and almost therapeutic warmth without any concealed meanings.

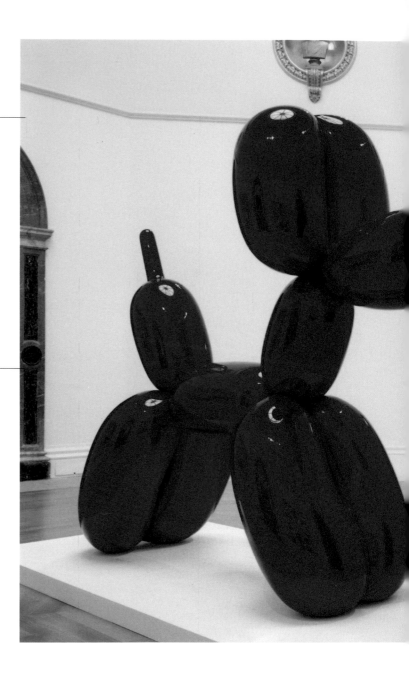

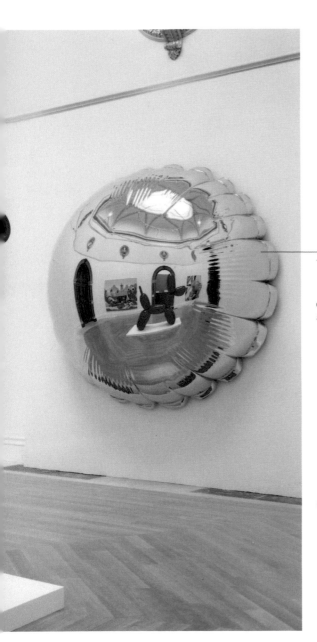

The perfect, tactile quality of the sculptures strengthens the artist's concern with construction and careful detailing. Built by teams of experts, these objects are true masterpieces of craftsmanship and technology, with a material like steel being worked to the extreme limits possible. The smooth surface with its mirror finish incorporates the viewer and reflects the surrounding reality directly, conveying enthusiasm and the quest for happiness.

Balloon Dog
1994–99
High chromium
stainless steel
with transparent
color coating
307.3 × 363.2 × 114.3 cm

Moon
1995–99
High chromium
stainless steel
with transparent
color coating
310.5 × 310.5 × 98.7 cm

Tulips
1995–2004
High chromium stainless steel
with transparent color coating
212.1 × 407 × 502 cm

One of the "Celebration" series, this joyful
bundle of steel tulips five meters long is
conceived to surprise the viewer in a public
setting, where its presence will be
unexpected. By setting the tulips on an
artificial "pond", the glossy effect of the
metal surface is amplified and helps create
an image half-way between the fabulous and
the pictures in a mail order catalogue.
Through a sense of emptiness, artificiality
and seduction, Koons attracts the viewer's
eye to the work and then reflects it again
towards the reality it mirrors.

Play-Doh
1995–2004
Oil on canvas
334 × 282.2 cm

Play-Doh forms part of a first group of
paintings that constitute the "Celebration"
series. The image is a colored heap of
plasticine placed on silver wrapping paper
that reflects its chromatic contrasts through
a kaleidoscopic composition. Unlike the
paintings Koons produced in later years,
these works represent individual objects
close up. Realized in hyperrealist style, the
images linked to childhood seem to invade
the viewer's visual space and communicate
an engrossing and joyful universe.

Loopy
1999
Oil on canvas
274.3 × 200.7 cm

Loopy belongs to the "Easyfun" series in which Koons juxtaposes different objects as in a collage: a dollop of whipped cream topped with a cherry, a sort of necklace of popcorn, a smiling comic-book bunny and a group of circles that make the image lively and dynamic. This is again a colorful, absorbing image that harmoniously embodies reality and fiction; the childlike images seem to devour the space and swallow animated desires, dreams and fantasies.

Though related to the Pop tradition of artists like James Rosenquist, the paintings by Koons lack political or psychological implications. Baroque in their spatial complexity, the works in the "Easyfun" series consist of fragments of images complete in their smallest details. The various figures are first projected onto canvas, then defined in their outlines and subsequently hand-painted to simulate the photographic effect of the original sources.

Here the backdrop is a fragmented image of Mount Rushmore with the heads of presidents. This work deals with identity and the need to believe in ourselves. In a sense the painting seems to say that everyone can become president, a message completed by the touch of optimism infused by the spurting milk. Though the artist discourages a critical reading of his works, *Cut-Out* looks like a complex game of seduction and a metaphor of the American dream.

Cut-Out
1999
Oil on canvas
274.3 × 201.3 cm

Every part of the painting is executed using different techniques of illustration. While the concrete objects reveal a hyperrealist style, the horse's head is rendered with the same comic-book language that characterizes this fun-fair figure. But the space where the children enjoy inserting their faces is taken up by an explosion of the well-known Cheerios cereal, taken from the seductive publicity photo that appears on the packet.

Donkey
2000
Polished stainless steel
381 × 304.8 × 18.1 cm

The sculptures in the "Easyfun" series
consist of colored mirrors traced on
the outlines of comic-book creatures.
These works express a minimalist simplicity
immediately negated by the frivolity
and playfulness of the forms, which project
the viewer into a fabulous world. *Donkey*
also represents a two-dimensional surface,
but this is contradicted by the mirror that
incorporates the setting in the work.
The reflective quality of the sculpture evades
any search for implicit depth by revealing
both the contradictions of society
and those of the art system.

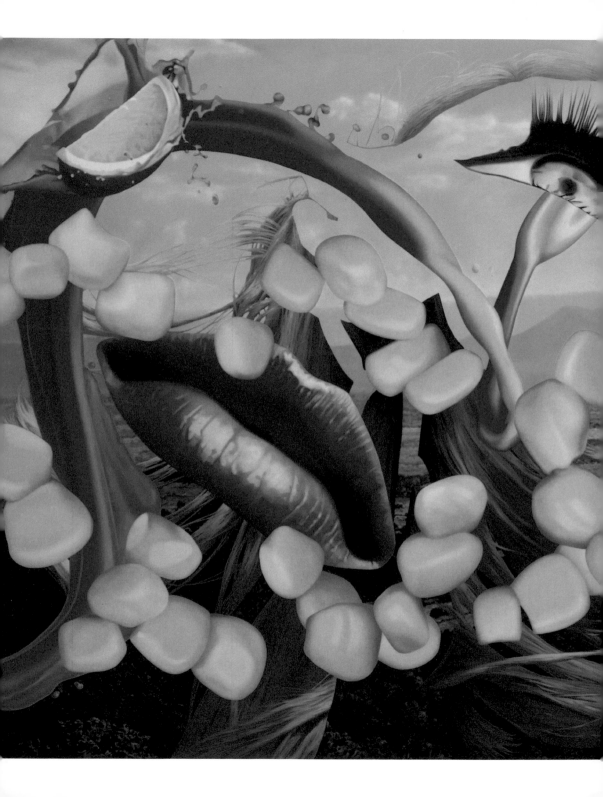

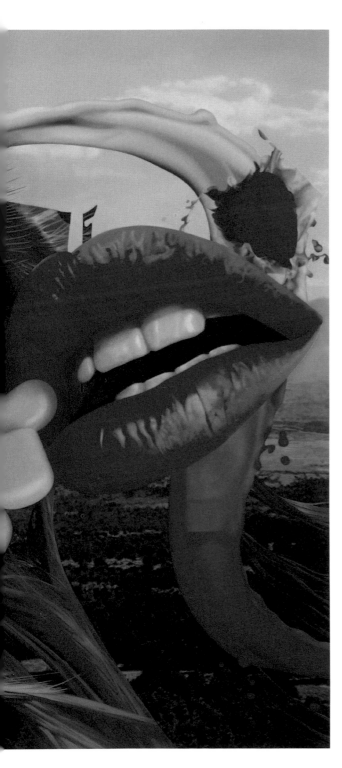

Lips
2000
Oil on canvas
300 × 430 cm

In *Lips* a childlike fairy-tale world is interwoven with the seductive image of food and fashion. Set between full lips, eyes heavily made up and locks of women's hair a constellation of grains of corn emerges with enticing spurts of orange juice. In the Pop tradition, Koons composes puzzles with seductive fragments of images taken from adverts that give life to surreal and sparkling visions. The work avoids passing judgment on consumer society but emphasizes the power of popular symbols to provide sensory satisfaction.

Split-Rocker
2000
Stainless steel, soil, geotextile fabric, internal
irrigation system, live flowering plants
1220 × 1180.1 × 1080 cm

Another outsize sculpture, *Split-Rocker*
represents the head of a child's rocking chair.
It is a hybrid, half pony and half dinosaur,
with handles for the child to hold on
at the sides. This work, in its exaltation
of a childhood world, also presents a
contemporary icon that conflicts with the
tradition of ancient celebratory statuary.
Made up of thousands of plants kept alive
by a system of irrigation, the work confronts
the relation between nature and artifice,
propaganda and consumption, nostalgia
and innocence.

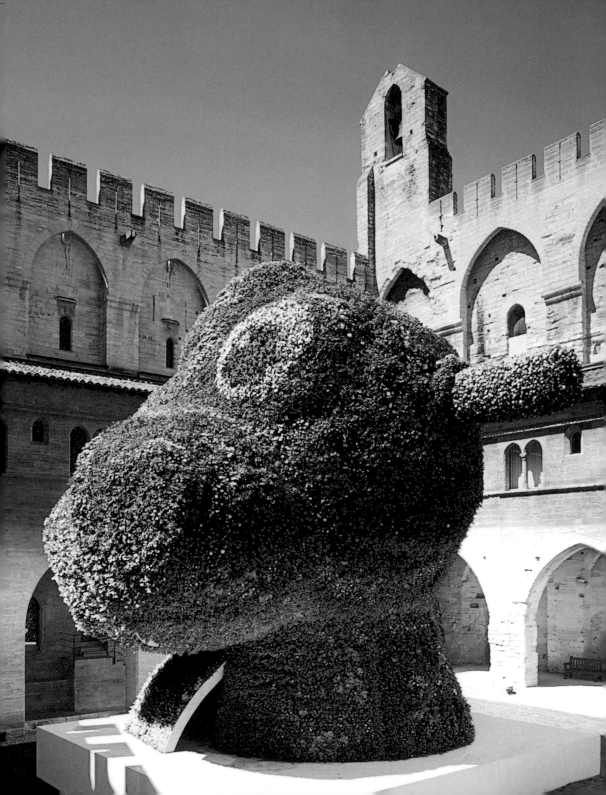

Elephants
2001
Oil on canvas
259.1 × 426.7 cm

The objects that Koons combines in his
paintings evoke implicit forms of which
not even fragments often remain visible but
merely their outlines. The figure of a kneeling
woman is eliminated, with the exception
of her hair and leather trousers, replaced
by cut-outs of elephants and jeweled bikinis
on invisible bodies. Manipulated by
computer, Koons's image-collages give
concrete form to popular dreamlike and
absurd images that devour the space of the
composition giving life to claustrophobic yet
stimulating views of the whole.

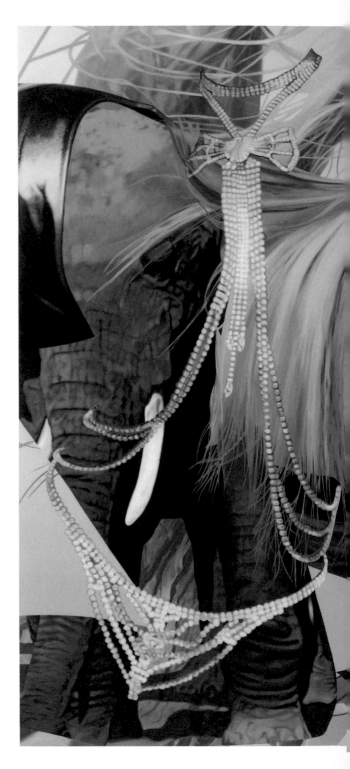

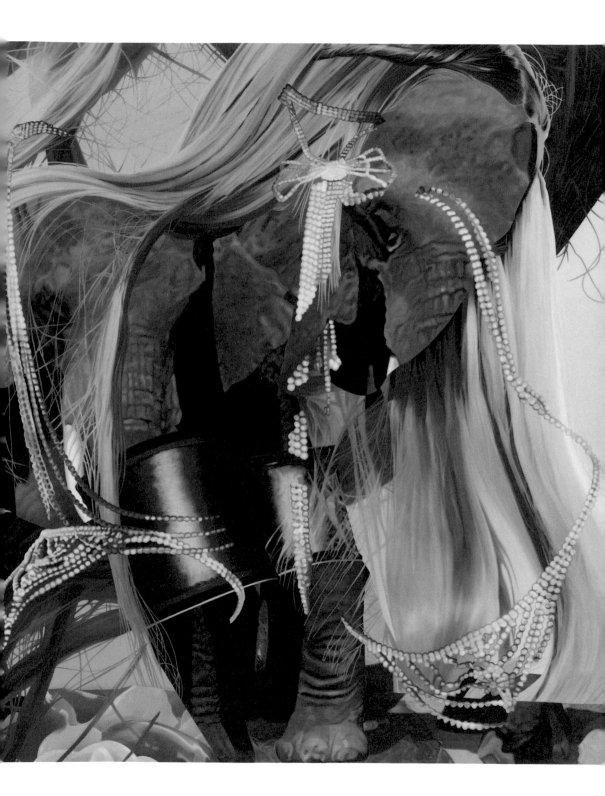

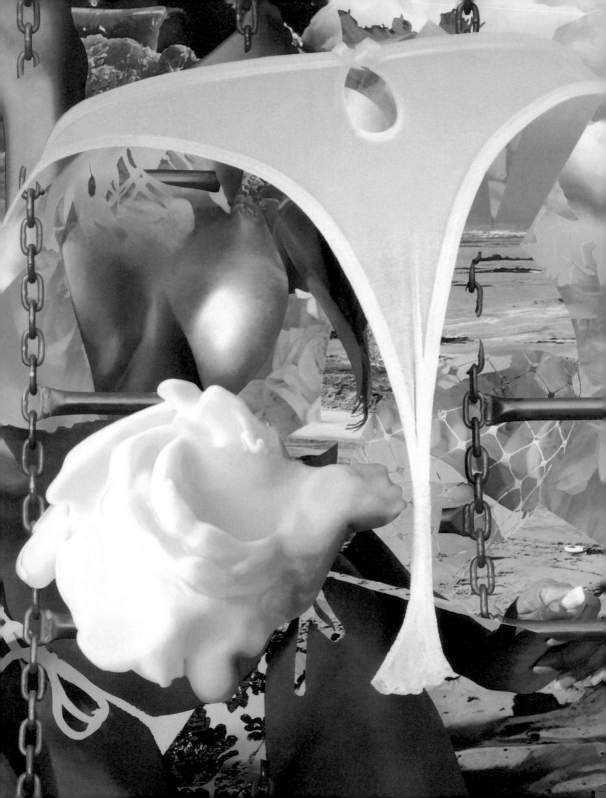

Butter
2002
Oil on canvas
274.3 × 213.4 cm

The full breasts of a woman's sensuous suntanned body is juxtaposed to a piece of butter whose consistency emphasizes the provocation of the nude skin. The idyll of the beach in the background is made ambiguous by the presence of a chain ladder, while the erotic message is obvious above all in the negative space framed by the white G-string. While Koons's approach never precludes the figural, his fantastic visions conjure up a world of abstract and fragmentary desires, a form of fetishism that takes concrete form in a synthesis of contemporary stereotypes.

Dolphin
2002
Polychromed aluminum, stainless steel,
rubber-coated steel
127 × 200 × 97.2 cm

An anomalous work in Koons's output,
Dolphin presents neither the irony
of his previous sculptures nor the playful
complexity of his paintings. An inflatable
dolphin is suspended by chains above and
in turn supports a series of kitchen utensils.
The artist plays on the contradiction between
lightness and heaviness and the relationship
between conflicting objects. But ultimately
both the toy animal and the saucepans,
indispensable utensils associated with
the idea of household chores, are bound
together in the name of mass consumption.

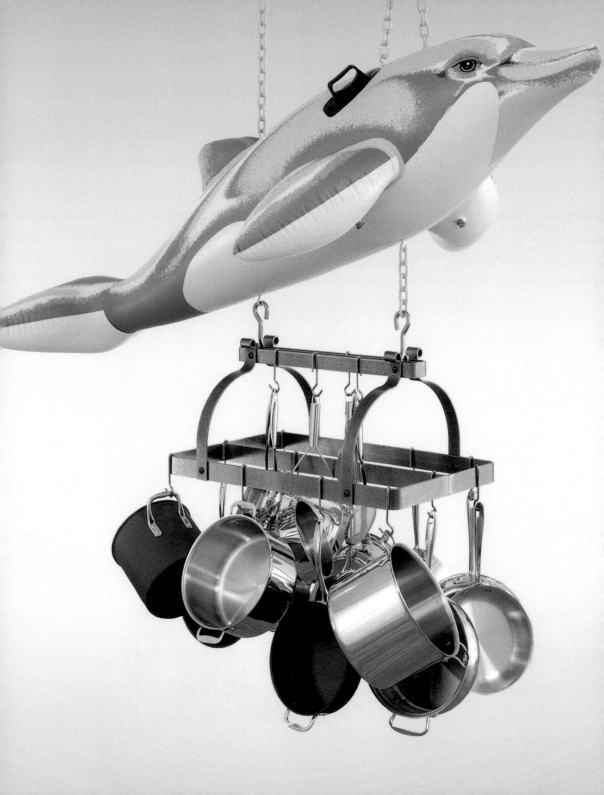

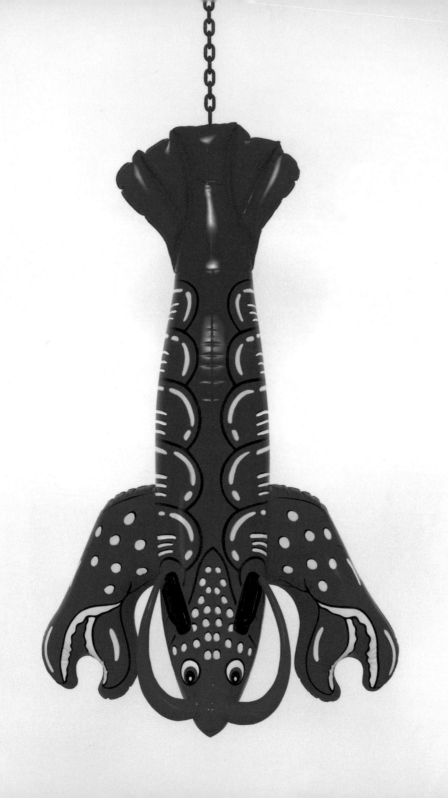

Lobster
2003
Polychromed aluminum, steel, vinyl
144.8 × 43.2 × 94 cm

A symbol used by Koons in various works,
the lobster represents a clear tribute to
Salvador Dalí, evoked even by its "whiskers."
Dalí, together with the various
representatives of American Pop Art, was
the most important influence on Koons's
outlook and technique. He also creates a
surreal world, though (unlike Dalí) working
with extreme awareness, as in the way he
incorporates emblems from popular imagery
and the media. The inflatable lobster hung
from the ceiling represents play and
lightness while in its precariousness
it is superimposed on reality from every
point of view.

In the "Easyfun-Ethereal" series to which this painting belongs, Koons achieves a new state of perfection in using the technique of digital interwoven forms. The images he chooses, created at the computer and then restored to painting through the use of oil colors, are not superimposed but, unlike the Pop artists who preceded him in the sixties, are interwoven on the canvas to form an independent web. This is a complex approach to figural art that juxtaposes forms, outlines and contents while denying the predominance of one image over another.

In this visual kaleidoscope we recognize comic-book icons which are also tributes to American Pop Art. Superman in fact is a direct quotation from a work by Warhol while Popeye is related to Lichtenstein. These two representations intersect with images taken from men's magazines, landscapes and children's games and in turn absorbed into the outline of a woman.

There is a sense of infinite animation that does not indicate a movement within the painting but derives from the movements our eyes perform in connecting the different fragments. Koons's paintings, though closely related to media images, reject the lithographic mechanisms of his predecessors and seek to achieve the pictorial precision of photorealism.

Olive Oyl
2003
Oil on canvas
274.3 × 213.4 cm

Popeye
2003
Oil on canvas
274.3 × 213.4 cm

Comic strip and reality, two-dimensionality
and volume, kitsch and tradition, Koons's
popular imagery embodies the antitheses
and paradoxes of the contemporary
universe. His meticulous oil paintings
eliminate all forms of iconographic and
stylistic hierarchy in favor of an objectivity
that rejects any kind of critical interpretation.
Popeye in the style of Lichtenstein appears
together with an inflatable lobster, a symbol
of Dalí's Surrealism: it is in this way
that the history of art and animated
cartoons are combined to form the
mythology of the present.

Saddle
2003
Oil on canvas
350.5 × 259.1 cm

Though it is a facile association to think
of a saddle in terms of its sexual significance
or as a symbol of an elitist pastime, Koons
chooses to deny a narrative interpretation
of the image, or at least to make it
ambiguous and therefore difficult to unify.
Parts of a woman's body taken from
a pornographic magazine contrast with
a tender-looking inflatable puppy.
All the aspects of the artist's universe
are fragmentary, composite and elusive
except for the pictorial qualities, which never
compromise the absolute hyperrealist
perfection of the painting.

appendices

Biography

Jeff Koons was born in York, Pennsylvania, in 1955. At an early age he revealed an artistic vocation, which his parents encouraged by enrolling him in drawing courses and enthusiastically displaying his "works" in the family's furniture store. In 1972 Koons began to study painting at the Maryland Institute College of Art, from which he graduated in 1976. In 1975–76 he attended the school of the Art Institute of Chicago, where the teachers included Jim Nutt and and Ed Paschke, representatives of the Chicago School of Pop whom he greatly respected.

Arriving in New York in 1977, he began to work at the membership desk of the Museum of Modern Art. In three years at MoMA, in addition to the opportunity he had to view some of the greatest masterpieces of twentieth-century art, Koons boosted donations from the friends of the museum, revealing an uncommon entrepreneurial flair. To finance the works he was making at the same time, Koons began to sell shares on commission at the Wall Street stock exchange. This experience working in close contact with the market in those boom years not only gave him the means to develop his ideas but also had a considerable influence on his approach to art.

Koons's first exhibition, "The New," held in 1980 at the New Museum in New York, revealed his fascination with mass-produced consumer goods, while "Equilibrium" in 1985, which presented the series of Nike posters, a fish tank containing basketballs and a bronze sculpture of an inflatable dinghy, revealed him as one of the most important artists of the day. From this time on his career developed rapidly. In SoHo Koons created a studio-workshop very much like Andy Warhol's Factory and took on dozens of assistants to deal with different aspects of the production of his artworks.

After his early conceptual works, in which he looked at media models and symbols and their social impact, in the mid-eighties Koons's Pop approach was embodied in celebrations of kitsch icons and contemporary banality. The series entitled "Banality" included outsize steel sculptures of puppets and toys and culminated in 1988 with *Michael Jackson and Bubbles*, a ceramic statue covered in gold leaf that sold at Sotheby's three years later for the record figure of $5,600,000. Ever since Koons has been a star of the world art scene and auction prices of his works have spiraled upwards. Thanks to major solo exhibitions in important museums and galleries in many countries, his reputation continued to grow, though there are critics who have dismissed his work as cynical and superficial.

In 1991 Koons married the Hungarian-born porno-star Ilona Staller, an Italian citizen who became involved in politics and was elected to the Italian Parliament (1987–92). The series of paintings, photos and sculptures "Made in Heaven," dating from the early 1990s, portrayed the artist and Cicciolina (Staller's *nom de guerre*) engaged in explicit sex acts, and further scandal surrounded the already controversial artist. In 1992 the couple had a son, Ludwig, but their marriage failed soon after. The harsh legal battle for custody of the child continued for years and still awaits a final settlement, leaving a profound mark on the artist and his development.

In 1992 Koons was commissioned to produce a work for an exhibition at Bad Arolsen in Germany. He astonished everyone by presenting *Puppy*, a sculpture thirteen meters high representing a terrier made out of thousands of flowers planted on a metal frame covered with soil. In 1995 the sculpture, acclaimed as one of his major masterpieces, was dismantled and reinstalled in Sydney Harbour on a new and more solid steel structure and equipped with an internal irrigation system. Subsequently, in 1997, the Guggenheim Foundation acquired the work and exhibited it on the terrace of the Bilbao Museum. During the inauguration, a trio disguised as gardeners tried to hide some explosives in the flower pots but were luckily discovered by the police. In the later nineties Koons also produced the "Celebration" series, where the Pop spirit emerged forcefully in giant sculptures and brightly colored paintings that celebrated the world of children and a kitsch universe. (In 1999 the artist even commissioned a song about himself from the Momus group, who included it in their album *Stars Forever*).

Since 2000 his painting has evolved into the "Easyfun" series as well as the later "Easyfun-Ethereal," in which fragments of images are combined as in a collage and then assembled on canvas. Koons, always known for his meticulous concern for detail, still continues to produce new and spectacular works assisted by a large team of skilled assistants.

Nominated a Fellow of the American Academy of Arts and Sciences in 2005, Jeff Koons continues to play a key role in contemporary art. Inevitably his works have not only influenced a generation of artists but continue to provide an interpretation of reality that is rich in stimulating new ideas and insights.

Recognitions and Exhibitions

Awards and Honors

2005
Creative Patronage Award, Cranbrook Academy of Art, Bloomfield Hills
Nominated to the American Academy for Arts and Sciences

2003
Museum of Fine Arts School Medal Award, Boston

2002
Appointed to Board of Directors, International Centre for Missing and Exploited Children
Membership to the Signet Society for Arts and Letters at Harvard University
Doctor of Fine Arts, Honoris Causa, The Corcoran Gallery, Washington, D.C.
Global Vision Award, Second Annual Hope Awards, National Center for Missing and Exploited Children, Arlington
Skowhegan Medal for Sculpture, Skowhegan School of Arts

2001
Chevalier de la Légion d'Honneur, nominated by Jacques Chirac and presented by Jean-Jacques Aillagon, President of Centre Georges Pompidou, Paris (May 16, 2001)

2000
BZ Cultural Award, City of Berlin

1999
Art Start for Children Award, Learning Through Art/The Guggenheim Museum Children's Program

Solo Exhibitions

2005
"Jeff Koons," Lever House, New York

2004
"Jeff Koons: Retrospective,"
Astrup Fearnley Museum of Modern Art, Oslo (September 4–December 12); Helsinki City Art Museum, Helsinki (January 28–April 10, 2005)
"Jeff Koons: Highlights of 25 Years," C & M Arts, New York
"GOAT: Greatest of all Time a Tribute to Muhammad Ali," Max Hetzler, Berlin (January 17–February 14)
"Jeff Koons: Backyard," Max Hetzler, Berlin (January 17–February 14)
2003 "Popeye," Sonnabend Gallery, New York
"Jeff Koons," Museo Archeologico Nazionale, Naples (Italy) (June 9–September 15, 2003)

2002
"Jeff Koons," Sonnabend Gallery, New York
"Jeff Koons: Paintings, Photos, Prints 1980–2002," Kunsthaus, Bielefeld
"Jeff Koons," York College, York (PA)
"Easyfun-Ethereal," Guggenheim Museum, New York
"Easyfun-Ethereal," 25th Sao Paulo Biennial, Sao Paulo

2001
"Jeff Koons," Kunsthaus Bregenz, Bregenz (Austria)
"Easyfun-Ethereal," Fruitmarket Gallery, Edinburgh
"New Paintings," Gagosian Gallery, Los Angeles

2000
"Easyfun–Ethereal," Deutsche Guggenheim, Berlin
"Puppy," Rockefeller Center, New York
"Split-Rocker," Papal Palace, Avignon

1999
"Jeff Koons, A Millennium Celebration," Deste Foundation, Athens

"Easyfun," Sonnabend Gallery, New York

1998
"Jeff Koons: Encased Works," Anthony d'Offay Gallery, London

1997
"Puppy," Guggenheim Museum Bilbao, Bilbao (permanent collection)
"Jeff Koons," Galerie Jérôme de Noirmont, Paris (catalogue)

1995
"Puppy," Museum of Contemporary Art, Sydney

1994
"Jeff Koons: A Survey 1981–1994," Anthony d'Offay Gallery, London

1993
"Jeff Koons Retrospective," Walker Art Center, Minneapolis
"Jeff Koons Retrospective," Aarhus (catalogue)
"Jeff Koons Retrospective," Staatsgalerie Stuttgart, Stuttgart (catalogue)

1992
"Jeff Koons Retrospective," San Francisco Museum of Modern Art, San Francisco (catalogue)
"Jeff Koons Retrospective," Stedelijk Museum, Amsterdam (catalogue)
"Made In Heaven," Galerie Lehmann, Lausanne
"Made In Heaven," Christophe Van de Weghe, Brussels

1991
"Made In Heaven," Sonnabend Gallery, New York
"Made In Heaven," Galerie Max Hetzler, Cologne

1989
"Jeff Koons-Nieuw Werk," Galerie 'T Venster, Rotterdamse Kunststichting, Rotterdam

1988
"Jeff Koons," Museum of Contemporary Art, Chicago (catalogue)
"Banality," Sonnabend Gallery, New York
"Banality," Galerie Max Hetzler, Cologne
"Banality," Donald Young Gallery, Chicago

1987
Daniel Weinberg Gallery, Los Angeles

1986
International With Monument Gallery, New York
Daniel Weinberg Gallery, Los Angeles

1985
International With Monument Gallery, New York
Feature Gallery, Chicago

1980
"The New" (a window installation), The New Museum of Contemporary Art, New York (May 29–June 26)

Group Exhibitions

2006
"'Where are We Going': Selections from the François Pinault Collection," Palazzo Grassi, Venice (April 30–October 1) (catalogue)
"Infinite Painting: Contemporary Painting and Global Realism," Villa Manin Centro d'Arte Contemporanea, Codroipo (Udine, Italy) (April 9–September 24) (catalogue)

2005
"Nudes in Vogue," Mitchell-Innes & Nash, New York (November 18–December 23)
"Contemporary Art Part I May 12, 2005, New York," Phillips de Pury & Company, New York
"Douglas Gordon's The

Vanity of Allegory," Deutsche Guggenheim, Berlin (July 16–October 9)
"36 Art Basel," Basel (June 20–25)
"Translation," Palais de Tokyo, Paris (June 23–September 18)
"Ed Paschke Tribute Show," Gallery 415, Chicago (April 8–July 8)
"Home Style," Leo Castelli Gallery, New York (April 1–May 27)
"Universal Experience: Art, Life, and the Tourist's Eye," Museum of Contemporary Art, Chicago (February 12–June 5); Hayward Gallery, London (October 6–December 11)
"Logical Conclusions," Pace Wildenstein, New York (February 18–March 26)

2004
"Happy Birthday!" Galerie Jerome de Noirmont, Paris (November 26, 2004–January 26, 2005)
"What's Modern?," Gagosian Gallery, New York (November 5–December 18)
"Artists' Favourites," Institute of Contemporary Arts, London (July 30–September 5, 2004)
"Monument to Now: The Dakis Joannou Collection," Deste Foundation for Contemporary Art, Athens (June 22–December 31)

2003
"Hverdagsestetikk (Everyday Aesthetics)," Astrup Fearnley Museet for Moderne Kunst, Oslo (September 27–November 30)
"The Daimler Chrysler Collection–100 Artists Out of More than 60 Years," Museum für Neue Kunst, ZKM Karlsruhe (May 24–August 31); The Detroit Institute of Arts, Detroit (October 26, 2003–January 2004)
"Aftershock: The Legacy of the Readymade in Post-War and Contemporary American

Art," Dickinson Roundell Gallery, New York (May 5–June 20)
"Strangely Familiar: Approaches to Scale in the Collection of The Museum of Modern Art, New York," The New York State Museum, New York (April 5–June 29)
"Painting Pictures: Painting and Media in the Digital Age," Kunstmuseum, Wolfsburg (February 28–June 29)

2002
"Flowers: Jeff Koons / Andy Warhol," Gagosian Gallery, New York (November 11–December 21)
"From Pop to Now: Selections from the Sonnabend Collection," The Tang Museum, Saratoga Springs (NY) (June 22–September 29); The Wexner Center for the Arts, Columbus (November 2)
"Group Show," Sandra Gering Gallery, New York (June 16–August 30)
"The Physical World," Gagosian Gallery, New York (May 9–June 29)

2001
"Jasper Johns to Jeff Koons: Four Decades of Art from the Broad Collection," Los Angeles County Museum of Art, Los Angeles (October 7, 2001–January 6, 2002); The Corcoran Gallery of Art, Washington, D.C. (March 16 –June 3, 2002); Museum of Fine Arts, Boston (July 28–October 20, 2002); Guggenheim Museum, Bilbao (February 15–September 7, 2003)
"Warhol / Koons / Hirst: Cult and Culture, Selections from the Vicki and Kent Logan Collection," Aspen Art Museum, Aspen (August 3–September 30)
"Play's the Thing: Critical and Transgressive Practices in Contemporary Art," Whitney Museum of American Art,

Independent Study Program Exhibition, Art Gallery of the Graduate Center The City University of New York (May 25–July 8)
"Jeff Koons," Sonnabend Gallery, New York (May 12–July 27)
"Collaborations with Parkett: 1984 to Now," Museum of Modern Art, New York (April 3–June 12)
"Give & Take," Serpentine Gallery and Victoria and Albert Museum, London (January 30–April 1) (catalogue)

2000
"Hypermental, 1950–2000 from Salvador Dalí to Jeff Koons," Kunsthaus, Zurich (November 17, 2000–January 21, 2001)
"Au-dela du spectacle," Centre Pompidou, Paris (November 19, 2000–January 8, 2001)
"Actual Size," Museum of Modern Art, New York (October 19, 2000–January 30, 2001)
"MoMA 2000," Museum of Modern Art, New York (October 7, 2000–February 13, 2001)
'Matter," Museum of Modern Art, New York (September 28, 2000–January 2, 2001)
"Pop and After," Museum of Modern Art, New York (September 28, 2000–January 2, 2001)
"Innocence and Experience," Museum of Modern Art, New York (September 28, 2000–January 2, 2001)
"Apocalypse: Beauty & Horror in Contemporary Art," Royal Academy of Arts, London (September 19–)
"Almost Warm and Fuzzy," Tacoma Art Museum, Tacoma (July 8–September 17)
"Around 1984: A Look at Art in the Eighties," P.S.1, New York (May 21–)
"Lets Entertain," Portland Museum of Art, Portland (July–September)
"Sonnabend Retrospective,"

Sonnabend Gallery, New York
"La Beaute," Avignon (May 25–)
"Sculpture," James Cohan Gallery, New York (March 8–April 1)
"Inner Eye," Neuberger Museum of Art, New York (January 30–April 16)

1999
"A Celebration of Art," 25th Anniversary of the Hirshhorn Museum and Sculpture Garden, Washington, D.C. (October 13–November 29)
"The American Century, Part II," Whitney Museum of American Art (September)
"Transmute," Museum of Contemporary Art, Chicago (September–November 1999)
"Gesammelte Werke 1-Zeitgenössische Kunst Seit 1968," Kunstmuseum, Wolfsburg (July 17–October 3)
"Heaven," Kunsthalle, Dusseldorf (July 30–October 17); Tate Gallery, Liverpool (December, 1999–January 2000)
"La Casa," Residence of Mauro Nicoletti, Rome (June 3–27) (catalogue)
"L'objet photographieque 2," Galerie d'art contemporain, Mourenx (March 19–April 14)
"The Virginia and Bagley Wright Collection," Seattle Art Museum, Seattle (March 4–May 9, 1999) (catalogue)
"Decades in Dialogue: Perspectives on the MCA Collection," Museum of Contemporary Art, Chicago (February 27–)
"Art at Work: Forty Years of The Chase Manhattan Collection," Museum of Fine Arts and the Contemporary Arts Museum, Houston (March 3–May 2)

1998
"Six Americans," Skarstedt Fine Art, New York (December 15,

1998–February 13, 1999)
"L'Envers du Décor, Dimensions décoratives dans l'art du XXe siècle," Musée d'art moderne Lille Métropole, Villeneuve d'Ascq (France) (October 17, 1998–February 21, 1999)
"A Portrait of Our Times: An Introduction to the Logan Collection," San Francisco Museum of Modern Art, San Francisco (September 29, 1998–January 3, 1999)
"Kunstausstellung Holderbank," Holderbank Management und Beratung AG (July 4–September 30)
"Double Trouble, The Patchett Collection," Museum of Contemporary Art, San Diego (June 27–September)
"Un monde merveilleux, Kitsch et Art Contemporain," Frac Nord-Pas de Calais, Dunkerque (France) (June 16–September 12)
"Interno-Esterno/Alterno," FENDI, New York (June 1–7) (catalogue)
"Fischli & Weiss, Clay Ketter, Jeff Koons," Sonnabend, New York (June 6–)
"Urban," Tate Gallery Liverpool, Liverpool (May 23, 1998–April 1999)
"Fast Forward-Trade Marks," Kunstverein in Hamburg, Hamburg (May 8–June 21)
"René Magritte and the Contemporary Art," Museum voor Moderne Kunst, Ostende (April 4–June 28) (catalogue)
"Tuning Up #5," Kunstmuseum Wolfsburg, Wolfsburg (March 7–August 9)
"Art in the 20th Century: Collection from the Stedelijk Museum Amsterdam," Ho-Am Art Museum, Seoul (January 17–Mary 15)

1997
"Hospital," Galerie Max Hetzler, Berlin (November 29, 1997–January 10, 1998)
"Group Show," The Eli Broad Family Foundation, Santa Monica (December 12–)

"Kunst Arbeit," Sudwest LB Forum, Stuttgart (November 15, 1997–January 11,1998) (catalogue)
"Dramatically Different," Centre National D'Art Contemporain de Grenoble, Genoble (October 26, 1997–February 1, 1998) (catalogue)
"A House is not a Home," Center for Contemporary Art, Amsterdam (October 17–December 14)
"On the Edge: Contemporary Art from the Werner and Elaine Dannheisser Collection," Museum of Modern Art, New York (September 30, 1997–January 20, 1998) (catalogue)
"Envisioning the Contemporary: Selections from the Permanent Collection," Museum of Contemporary Art, Chicago (June 21, 1997–April 5, 1998)
"Futuro Presente Passato: La Biennale di Venezia," Venice (June 15–November 9) (catalogue)
"Objects of Desire: The Modern Still Life," Museum of Modern Art, New York (May 25–August 26) (catalogue)
"Multiple Identity: Amerikanische Kunst 1975–1995 Aus dem Whitney Museum of American Art," Kunstmuseum, Bonn (June 4–September 7); Castello di Rivoli, Museo d'Arte Contemporanea, Rivoli (Italy) (October 20, 1997–January 18, 1998) (catalogue)
"Autoportraits," Galerie Municipale du Chateau d'Eau, Toulouse (July 4–September 8)
"Family Values: American Art in the Eighties and Nineties," The Scharpff Collection at the Hamburger Kunsthalle, Hamburg (catalogue)
"Belladonna," Institute of Contemporary Arts, London (January 24–April 12)
"It's Only Rock and Roll:

Rock and Roll Currents in Contemporary Art, Phoenix Art Museum, Phoenix (March 22–June 15)
"Objects of Desire: The Modern Still Life," Museum of Modern Art, New York (May 14–September 2) (catalogue)

1996
"Art at Home-Ideal Standard Life," curated by Takayo Lida, Spiral Garden, Tokyo (April 26–May 5); Gallery Soemi, Seoul (July 18–August 10) (catalogue)
"a/drift," curated by Joshua Decter, Center for Curatorial Studies Museum, Bard College, Annandale-on-Hudson (October 20, 1996–January 5, 1997)
"Playpen & Corpus Delirium," Kunsthalle, Zurich (October 5–December 29) (catalogue)
"Just Past: The Contemporary in MOCA's Permanent Collection, 1975–96," The Geffen Contemporary, Museum of Contemporary Art, Los Angeles (September 29, 1996–January 19, 1997)
"Contemporary Art 1960–1995: Selections from the Permanent Collection," The San Francisco Museum of Modern Art, San Francisco
"Art at the End of the 20th Century. Selections from the Whitney Museum of American Art," National Gallery, Alexander Soutzos Museum, Athens (June 10–September 30); Museu d'Art Contemporani, Barcelona (December 18, 1996–April 6, 1997); Kunstmuseum, Bonn (June–September 1997) (catalogue)
"Everything That's Interesting Is New: The Dakis Joannou Collection," Athens School of Fine Arts, Athens (January 20–April 20) (catalogue)
"The Human Body in Contemporary American Sculpture," Gagosian

Gallery, New York (February 1–March 2)
Inaugural opening of the Museum of Contemporary Art, MoCA, Los Angeles (February 23)

1995
"From Christo and Jean Claude to Jeff Koons: John Kaldor Art Projects and Collection," Museum of Contemporary Art, Sydney (December 12, 1995–March 17, 1996) (catalogue)
"Jeff Koons / Roy Lichtenstein," The Eli Broad Family Foundation, Santa Monica (December–).
"Group Show," organized by Jeff Koons, Nicole Klagsbrun Gallery, New York (July 7–August 10)
"Black Male: Representations of Masculinity in Contemporary American Art," Whitney Museum of American Art, New York (November 10, 1995–March 5, 1996) (catalogue); Armand Hammer Museum of Art and Cultural Center, UCLA, Los Angeles (April 25–June 18, 1996) (catalogue)
"A Collection Sculptures," Caldic Collection, Rotterdam (catalogue)
"Signs and Wonders," Kunsthaus, Zurich and Centro Galego de Arte Contemporanea, Galicia (catalogue)
"A Benefit Exhibition for D.E.A.F., Inc.," Organized by Jeff Koons, Nicole Klagsbrun Gallery, New York (July 12–28)
"Going for Baroque, The Contemporary and the Walters Art Gallery, Baltimore (September 24, 1995–February 4, 1996) (catalogue)
"Die Muse?," Thaddeaus Ropac Gallery, Salzburg
"Unser Jahrhundert," Museum Ludwig, Cologne (July 9–October 8)
"45 Nord & Longitude 0," CAPC Musee d'Art Contemporain de Bordeaux

(June 24–September 10)
"Florine Stettheimer Collapsed Time Salon," Jeffrey Deitch, The Gramercy International Art Fair, New York (April 28–May 1)

1994
"Tuning Up," Kunstmuseum Wolfsburg, Wolfsburg
"Face Off: The Portrait in Recent Art," Institute of Contemporary Art, University of Pennsylvania (September 9–October 30); Joslyn Art Museum, Omaha (January 28–March 19, 1995); Weatherspoon Art Gallery, University of North Carolina, Greensboro (April 9–May 28, 1995)
"Spielverderber," Forum Stadtpark, Graz
"Ou les oiseaux selon Schopenhauer," Musee des Beaux-Arts d'Agen
"Head and Shoulders," Brooke Alexander, New York (November 26–December 30)

1993
"The Return of the Cadvre Exquis," The Drawing Center, New York (November 6–December 18)
"Anniversary Exhibition, Part III," Daniel Weinberg Gallery, Santa Monica (September 15–October 16)
"American Art in the Twentieth Century," Royal Academy of Arts, London (September 16–December 12)
"Drawing the Line Against AIDS," AmFAR International, The Peggy Guggenheim Collection at the 45th Venice Biennale, Venice (June 8–June 13)
"Jeff Koons, Andy Warhol," Anthony D'Offay Gallery, London (June 16–June 21)
"Amerikanische Kunst im 20. Jahrhundert," Martin-Gropius-Bau, Berlin (May 8–July 25)
"1982–83: Ten Years After," Tony Shafrazi Gallery, New York (May 8–June 26)

"Jeff Koons, Roy Lichtenstein, Gerhard Merz, Albert Oehlen, Thomas Struth," Galerie Max Hetzler, Cologne (April 30–May 29)
"The Elusive Object," Whitney Museum of American Art at Champion, Stamford (CT) February 5–April 14)
"Zeitsprunge: Künstlerische Positionen der 80er Jahre," Wilhelm-Hack-Museum, Ludwigshafen am Rhein (January 17–February 28)
"Photoplay: Works from the Chase Manhattan Collection," Center for the Fine Arts, Miami (January 9–); Museo Amparo, Puebla, Mexico; Museo de Arte Contemporaneo de Monterrey, Monterrey, Mexico; Centro Cultural Consolidado, Caracas; Museu de Arte de Sao Paulo, Sao Paulo; Museo Nacional de Bellas Artes, Santiago (catalogue)

1992
"Al(l)ready Made," Museum voor Hedendaagse Kunst, 's-Hertogenbosch, The Netherlands (September 13–November 1)
"Strange Developments," Anthony d'Offay Gallery, London (September 10–October 16)
"Made For Arolsen," Schloss Arolsen, Arolsen (June 12–September)
"Post Human," Musee D'Art Contemporain Pully, Lausanne (June14–September 13); The Israel Museum, Jerusalem (June 21–October 10, 1993); Deictorhallen, Hamburg
"Group Show," Max Hetzler Gallery, Cologne (May 17–June 27)
"Selected Works from the Early Eighties," Kunstraum Daxler, Munich (July 15–September 5) (catalogue)
"Doubletake: Collective Memory & Current Art," Hayward Gallery, London (February 20–April 20)

1991
"Quindicesima Biennale Internazionale del Bronzetto Piccola Scultura," Palazzo della Ragione, Padua (October 27–)
"Group Show," American Fine Arts, Co., New York (September 14–October 12)
"Group Show," Luhring-Augustine-Hetzler, Santa Monica (September 12–October 12)
"Objects for the Ideal Home: The Legacy of Pop Art," Serpentine Gallery, London (September 11–October 20)
"Group Show,"Andrea Rosen Gallery, New York (September 7–October 5)
"Power: Its Myths, Icons, and Structures in American Culture, 1961–1991," Indianapolis Museum of Art, Indianapolis (September 7–November 3); Akron Art Museum, Akron (February–March 1992); Virginia Museum of Fine Arts, Richmond (May–June, 1992)
"Vertigo: 'The Remake,'" Galerie Thaddaeus Ropac, Salzburg (July 26–August 31)
"La Sculpture Contemporaine après 1970," Fondation Daniel Templon, Musée Temporaire, Frejus (July 4–September 29)
"Metropolis," Martin-Gropius-Bau, Berlin (April 20–July 21)
"About Collecting: Four Collectors, Four Spaces," Ronny Van De Velde, Antwerp (April 17–June 1)
"Gulliver's Travels," Galerie Sophia Ungers, Cologne (April 10–April 20)
"Word as Image," Contemporary Arts Museum, Houston (March 22–May 12)
"A Duke Student Collects: Contemporary Art from the Collection of Jason Rubell," Duke University Museum of Art, Durham (March 1–May 19) (catalogue)
"Toward a New Museum: Recent Acquisitions in Painting and Sculpture,

1985–91," San Francisco Museum of Modern Art, San Francisco
"Who Framed Modern Art or the Quantitative Life of Roger Rabbit," Sidney Janis Gallery, New York (January 10–February 9)
"Devil on the Stairs: Looking Back on the Eighties," Institute of Contemporary Art, University of Pennsylvania, Philadelphia (October 4, 1991–January 5, 1992) and Newport Harbor Art Museum, Newport Beach (April 16–June 21, 1992) (catalogue)
"Compassion and Protest: Recent Social and Political Art from the Eli Broad Family Foundation Collection," San Jose Museum of Art, San Jose (June 1–August 25) (catalogue)

1990
"Culture and Commentary: An Eighties Perspective," Hirshhorn Museum and Sculpture Garden, The Smithsonian Institution, Washington, D.C.
"Art = Money?," The Gallery, New York (November 29–December 23)
"Weitersehen (1980–1990)," Museum Haus Lange and Museum Haus Esters, Krefeld (November 18, 1990–January 27, 1991)
"Group Show," Galerie Max Hetzler, Cologne (November 2–December 15)
"The Charade of Mastery," Whitney Museum of American Art, Downtown at Federal Reserve Plaza, New York (October 31, 1990–January 11, 1991)
"Vertigo," Galerie Thaddaeus Ropac, Paris (October 26–)
"Einladung," Galerie Carola Mosch, Berlin (October 23)
"The Transformation of the Object," Grazer Kunstverein, Graz (October 14–November 8)
"High & Low: Modern Art and Popular Culture," Museum of Modern Art,

New York (October 7, 1990–January 15, 1991); The Art Institute of Chicago, Chicago (February 20–May 12, 1991); Museum of Contemporary Art, Los Angeles (June 21–September 15)
"Images in Transition: Photographic Representation in the Eighties," The National Museum of Modern Art, Kyoto (September 23–November 12)
"The Last Decade: American Artists of the '80s," Tony Shafrazi Gallery, New York (September 15–October 27); Jardines de Bagatelle," Galerie Tanit, Munich (September 15–October 28)
"Life-Size: A Sense of the Real in Recent Art," The Israel Museum, Jerusalem (September)
"Pharmakon '90," Mukuhari Messe Contemporary Art Exhibition, Tokyo (July 28–August 20)
"Artificial Nature," Deste Foundation for Contemporary Art, Athens (June 20–September 15)
"Aperto: Venice Biennale," Venice (May 27–September 30)
"The 8th Biennale of Sydney," Sydney (April 11–June 3)
"OBJECTives: The New Sculpture," Newport Harbor Art Museum, Newport Beach (April 8–June 24)
"1990–ENERGIES," Stedelijk Museum, Amsterdam (April 4–July 29)
"New Work: A New Generation," San Francisco Art Museum, San Francisco (February 22–April 22)
"The Indomitable Spirit," International Center of Photography at Midtown, New York (February 9–April 7) and the Los Angeles Municipal Art Gallery, Los Angeles (May 13–June 17)
"Prints and Multiples," Luhring, Augustine and Hetzler, Santa Monica (January 20–February 24)
"Horn of Plenty," Stedelijk

Museum, Amsterdam (January 14–February 19)
"Editionen von Jeff Koons," Galerie Gisela Capitain, Cologne (January 13–February 10)
"The Last Laugh," Massimo Audiello Gallery, New York (January 6–27)
"Work as Image in American Art: 1960–1990," Milwakee Art Museum, Milwaukee
"Culture and Commentary," Hirshhorn Museum, Smithsonian Institution, Washington, D.C.

1989
"Image World," Whitney Museum of American Art, New York (November 8, 1989–February 18, 1990)
"D&S Ausstellung," Kunstverein in Hamburg, Hamburg (October 14–November 26)
"Mit dem Fernrohr durch die Kunstgeschichte," Kunsthalle, Basel (August 20–October 29)
"Psychological Abstraction," Deste Foundation, Athens (July 19–September 16)
"The Silent Baroque," Galerie Thaddaeus Ropac, Salzburg (May 30–August 31)
"A Forest of Signs: Art in the Crisis of Representation," Museum of Contemporary Art, Los Angeles (May 7–August 13)
"1989 Whitney Biennial," Whitney Museum of American Art, New York (April 26–July 16)
"Conspicuous Display," Stedman Art Gallery, Rutgers University, Camden
"Suburban Home Life: Tracking the American Dream," Whitney Museum of American Art Downtown at Federal Reserve Plaza, New York

1988
"Three Decades: The Oliver-Hoffman Collection," Museum of Contemporary Arts, Chicago (December 17,

1988–February 5, 1989) (catalogue)
"The Carnegie International," The Carnegie Museum of Art, Pittsburgh (November 5, 1988–January 22, 1989)
"Hybrid Neutral: Modes of Abstraction and the Social," The University of North Texas Art Gallery, Denton (August 29–September 30); The J.B. Speed Art Museum, Louisville (November 7, 1988–January 2, 1989); Alberta College Gallery of Art, Calgary, Alberta (February 9–March 9, 1989); The Contemporary Arts Center, Cincinnati (March 31–May 6, 1989); Richard F. Brush Art Gallery, St. Lawrence University, Canton (NY) (October 12–November 15, 1989); Santa Fe Community College Art Gallery, Gainesville (February 4–March 18, 1989)
"L'Objet de L'Exposition," Centre National des Arts Plastiques, Paris, France (June 29–August 10)
"Collection Pour Une Region," CAPC, Musee d'Art Contemporain, Bordeaux (March 4–April 24)
"Artschwager: His Peers and Persuasion, 1963–1988," Daniel Weinberg Gallery, Los Angeles (March 5–April 2); Leo Castelli Gallery, New York (May 21–June 18)
"New York in View," Kunstverein München, Munich (February 26–April 3) (catalogue)
"Sculpture Parallels," Sidney Janis Gallery, New York (February 25)
"Schlaf der Vernumst," Museum Fridericianum, Kassel (February 21–May 23)
"Cultural Geometry," Dakis Joannou, Athens (January 18–April 17)
"Redefing the Object," University Art Galleries, Wright State University, Dayton
"New York Art Now–Part Two," Saatchi Collection, London

"Altered States," Kent Fine Art Gallery, New York
"A 'Drawing' Show," Cable Gallery, New York
"Art at the End of the Social," Rooseum Gasverksgaten, Malmö
"New York, New York," Galleria 57, Madrid
"Nancy Spero: Works Since 1950 and Jeff Koons," Museum of Contemporary Art, Chicago
"Works-Concepts-Processes-Situations-Information," Austellungsram Hans Mayer, Dusseldorf
"New Works," Daniel Weinberg Gallery, Los Angeles
"The BiNational," Institute of Contemporary Arts, Boston Museum of Fine Arts, and Kunsthalle, Dusseldorf

1987
"Collection Sonnabend," Centro de Arte Reina Sofia, Madrid, Spain and CAPC, Musee d'Art Contemporain, Bordeaux (October 30, 1987–February 15, 1988)
"NY Art Now," The Saatchi Collection, London (September 8–)
"New York New," Paul Maenz Gallery, Cologne (June 5–July 31)
"Post-Abstract Abstraction," The Aldrich Museum of Contemporary Art, Ridgefield (May 31–September 6)
"Avant-Garde in the Eighties," Los Angeles County Museum, Los Angeles (April 23–July 12)
"Les Courtiers du Desir," Galeries Contemporaines, Centre Georges Pompidou, Paris (April 15–May 24)
"1987 Whitney Biennial," Whitney Museum of American Art, New York (April 10–July 5)
"This is Not a Photograph: 20 Years of Large Scale Photography," The John and Marble Ringling Museum of Art, Saratosa (March 7–May 31); Akron Art Museum,

Akron (October 31, 1987–January 10, 1988); The Chrysler Museum, Norfolk (February 26–May 1)
"True Pictures," John Good Gallery, New York (January 9, 1987–February 7, 1988)
"Romance," Knight Gallery, Charlotte
"Skulptur Projekte in Münster 1987," Kulturgeschichte, Münster

1986
"Group Show," Galerie Max Hetzler, Cologne (November)
"Endgame: Reference and Simulation in Recent Painting and Sculpture," Institute of Contemporary Art, Boston (September 25–November 30)
"Prospect 86," Schirn Kunsthalle, Frankfurt (September 9–November 2)
"A Brokerage of Desire," Otis/Parsons Exhibition Center, Los Angeles (July 11–August 16)
"The Drawing Show," Pat Hearn Gallery, New York (June 20–)
"Modern Objects, A New Dawn," Baskerville & Watson, New York (June 5–August 2)
"New Sculpture," Renaissance Society, University of Chicago (May 7–June 21)
"Spirtual America," CEPA Galleries, Buffalo (May 3–June 15)
"Time After Time," Diane Brown, New York (March 8–April 2)
"Objects from the Modern World," Daniel Weinberg Gallery, Los Angeles (February 18–March 8)
"Group Show," Jay Gorney Modern Art, New York (January 10–February 2)
"Admired Work," John Weber Gallery, New York (January 9–February 8)
"Damaged Goods," The New Museum of Contemporary Art, New York (June 21–August 10);

Otis Parsons Exhibition Center, Los Angeles
"Paravision," Margo Leavin Gallery, Los Angeles and Donald Young Gallery, Chicago
"Group Show," Sonnabend Gallery, New York

1985
"Cult and Decorum," Tibor de Nagy Gallery, New York (December 7, 1985–January 4, 1986)
"Post Production," Feature, Chicago (December 6, 1985–January 11, 1986)
"Group Show," 303 Gallery, New York (November 5–December 1)
"New Ground," Luhring, Augustine & Hodes Gallery, New York (September 10–October 5)
"Affiliations: Recent Sculpture and its Antecedents," Whitney Museum of American Art at Champion, Stamford (CT) (June 28–August 24)
"Group Show," International With Monument Gallery, New York (June 12–July 14)
"Logosimuli," Daniel Newburg Gallery, New York (June 8–30)
"Paravision," Postmasters, New York (May 3–June 2)
"Objects in Collision," The Kitchen, New York (April 6–May 4)
"Signs II," Michael Klein Inc., New York
Galerie Crousel-Hussenot, Paris

1984
"The New Capital," White Columns, New York (December 4, 1984–January 5, 1985)
"Objectivity," Hallwalls, Buffalo (December 1–22)
"Light Moving," Kamikaze, New York (October 17–)
"A Decade of New Art," Artist's Space, New York (May 31–June 30)
"Pop," Spirtual America,

New York (February 1–)
"New Sculpture," School 33, Baltimore

1983
"Science Fiction," John Weber Gallery, New York (September 17–October 8)
"Los Angeles-New York Exchange," Artist's Space, New York (May 21–July 2); LACE, Los Angeles, California (June 8–July 16)
"Objects, Structures, Artifices," University of South Florida, Tampa (April 9–May 30); Bucknell University, Lewisburg (PA) (September 2–October 9)
"Hundreds of Drawings," Artist's Space, New York

1982
"A Fatal Attraction: Art and the Media," Renaissance Society, University of Chicago (May 2–June 12)
"A Likely Story," Artist's Space, New York (February 20–March 27)
"Energie New York," Espace Lyonnais D'Art Contemporain, Lyon

1981
"Lighting," P.S.1, Long Island City (February 15–April 5)
Annina Nosei Gallery, New York
"Moonlighting," Joseph Gallery, New York
Maryland Institute College of Art, Baltimore
Barbara Gladstone Gallery, New York

1980
"Art for the Eighties," Galeria Durban, Caracas

Bibliography

Books and Catalogues

2005
Contemporary Art/Evening Including Property from the Collection of Gianni Versace, Sotheby's, New York, May 10, 2005, pp. 88–93, 98–101 (back cover).
Logical Conclusions: 40 Years of Rule-Based Art, Pace Wildenstein, New York, pp. 104–05.
W.J.T. Mitchell, *What Do Pictures Want? The Lives and Loves of Images*, University of Chicago Press, Chicago, pp. 114–15, 120–24.
Post-War and Contemporary Art Evening Sale, Christie's, New York, May 11, 2005, pp. 182–85, 220–25 (back cover).
Takashi Murakami (ed.), *Little Boy: The Arts of Japan's Exploding Subculture*, Japan Society, New York, pp. 272, 275, 284–85.
Universal Experience: Art, Life, and the Tourist's Eye, Museum of Contemporary Art, Chicago, p. 89, 92.

2001
Au-Dela du Spectacle, Museé d'Art Moderne, Centre Pompidou, Paris, p. 66.
Stephanie Barron and Lynn Zelevansky, *Jasper Johns to Jeff Koons: Four Decades of Art from the Broad Collections*, with essays by Thomas Crow, Sabine Eckmann, Joanne Heyler Pepe Karmel, Los Angeles County Museum of Art, Los Angeles.
Give & Take, Serpentine Gallery, London, pp. 24, 25.
Michael Jackson and Bubbles by Jeff Koons, with essay by Allison Gingeras, Sotheby's, New York.

2000
Apocalypse, Royal Academy, London.
Karen Jacobson (ed.), *Let's Entertain: Life's Guilty Pleasures*, Walker Art Center, Minneapolis, pp. 25–26, 244, 246
Jeff Koons: Easyfun-Ethereal, Deutsche Guggenheim Berlin, Berlin.
MOCA Art Auction 2000, Museum of Contemporary Art, Los Angeles, p. 35.

1999
Matthew Collings, *This is Modern Art*, Orion Publishing Co., United Kingdom, pp. 38–39, 244, 248–51, 258, 260.
Katerina Gregos (ed.), *Jeff Koons*, Deste Foundation's Centre for Contemporary Art, Athens
Martin Kemp (ed.), *The Oxford History of Western Art*, Oxford University Press, Oxford, pp. 504–05.
Burkhard Riemschneider and Uta Grosenick (eds.), *Art at The Turn of the Millennium*, Taschen, Cologne, pp. 286–89.
Robert Rosenblum, *On Modern American Art*, Harry N. Abrams, New York, pp. 332–34.
The American Century, Art and Culture 1950–2000, Whitney Museum of American Art, New York, pp. 310, 319.

1998
Christie's Contemporary Art, November 12, pp. 20–21, 100–01, 119.
Tony Godfrey, *Conceptual Art*, Phaidon Press Limited, London, pp. 392, 394.
John Henry Merryman and Albert E. Elsen. *Law, Ethics and Visual Arts*, 3rd ed., University of Pennsylvania Press, Philadelphia, pp. 348–68.
Schlaf der Vernunft, Museum Fridericianum Kassel, Kassel, February 21–May 23, 111–15.
Tuning up #5, Kunstmuseum Wolfsburg, Wolfsburg.

1997–98
On the Edge, Contemporary Art from the Werner and Elaine Dannheisser Collection, Museum of Modern Art, New York, pp. 76–81.

1997
Objects of Desire: The Modern Still Life, Museum of Modern Art, New York, May 25–August 26, p. 205.

1996
Art at the End of the 20th Century: Selections from the Whitney Museum of American Art, Whitney Museum of American Art, New York, p. 26.
John Caldwell. "Jeff Koons: The Way We Live Now," in *This is About Who We Are: the Collected Writings of John Caldwell.* San Francisco Museum of Modern Art, San Francisco, pp. 183–96.
Family Values: American Art in the Eighties and Nineties, Hamburger Kunsthalle, Hamburg (cover), pp. 7, 8, 46–59.
Fractured Fairy Tales: Art in the Age of Categorical Disintegration, Duke University Museum of Art, Durham, April 12–May 25, pp. 63–66, 72.
Tate Report: Tate Gallery Biennial Report 1994–1996, Tate Gallery, London, p. 35.
Linda Weintraub, Arthur Danto, and Thomas McEvilley. *Art on the Edge and Over: Searching for Art's Meaning in Contemporary Society 1970s–1990s*, Art Insights, Inc., Litchfield (CT), pp. 27, 197–203.

1995
David S. Rubin. *It's Only Rock and Roll: Rock and Roll Currents in Contemporary Art*, Prestel, Munich-New York, pp. 9, 64–65, 152.

106

1993
Zeitsprünge, Wilhelm-
Hack-Museum,
Ludwigshafen am Rhein,
January 17–February 28,
pp. 46–57.

1992
*Doubletake: Collective
Memory and Current Art*,
Hayward Gallery, London,
February 20–April 20,
pp. 20, 176–79.
Angelika Muthesius (ed.),
Jeff Koons, Taschen,
Cologne.
Angelika Muthesius, *et al.*,
*Erotik in der Kunst 20
Jahrhunderts*, Taschen,
Cologne, pp. 36, 106–07,
127, 136.

1990
Peter Schjeldahl, "Jeff
Koons," *Objectives: The
New Sculpture*, Newport
Harbor Art Museum,
Newport Beach, pp. 82–99.

1988
Jeff Koons, Museum
of Contemporary Art,
Chicago, July 1–August 28.
New York in View,
Kunstverein Munchen,
Munich, February 26–April
3, pp. 5, 13, 25–33, 66.
Schlaf der Vernunft,
Museum Fridericianum
Kassel, Kassel, Germany,
February 21–May 23,
pp. 111–15.

1987
*Art and its Double: A New
York Perspective*, Fundacion
Caja de Pensiones, Madrid,
February 6–March 22,
pp. 61–73.
Biennial 1987, Whitney
Museum of American Art,
New, York, April 10–July 5,
p. 65.

1986
*Prospect 86: Eine
internationale Ausstellung
aktueller Kunst*, Frankfurter
Kunstverein, Frankfurt.,
September 9–November 2,
pp. 114–15.

Jerry Saltz, et al., *Beyond
Boundaries: New York's
New Art*, A. van der Marck
Editions, New York, pp. 4–7.

List of Works

Editorial Project
Enrica Melossi
Martina Mondadori

Graphics Coordination
Dario Tagliabue

Graphic Design
Francesca Botta

Cover
CDM Associati

Page Layout
Sara De Michele

Editorial Coordination
Maria Bugli

Editing
Gail Swerling

Translation
Richard Sadleir

Technical Coordination
Andrea Panozzo

Quality Control
Giancarlo Berti

Photograph Credits
© Studio Jeff Koons for illustrations of his works
AKG Images, Berlin: pp. 8, 9, 10, 11, 12

www.electaweb.com

This book was printed for Mondadori Electa S.p.A.
at Mondadori Printing S.p.A., Verona, in 2006